Alicia Imperiale

New Flatness

Surface Tension in Digital Architecture

Birkhäuser – Publishers for Architecture
Basel • Boston • Berlin

Original manuscript in English

A CIP catalogue record for this book is available from the Library of Congress, Washington D.C., USA.

Deutsche Bibliothek Cataloging-in-Publication Data

Imperiale, Alicia:

New flatness : surface tension in digital architecture / Alicia Imperiale. - Basel ; Boston ; Berlin : Birkhäuser, 2000

(The IT revolution in architecture)

ISBN 3-7643-6295-2

Original edition:
Nuove bidimensionalità (Universale di Architettura 86, collana fondata da Bruno Zevi; La Rivoluzione Informatica, sezione a cura di Antonino Saggio).
© 2000 Testo & Immagine, Turin

© 2000 Birkhäuser – Publishers for Architecture, P.O. Box 133, Ch-4010 Basel, Switzerland.
Printed on acid-free paper produced of chlorine-free pulp. TCF ∞
Printed in Italy
ISBN 3-7643-6093-3
ISNB 0-8176-6093-3

9 8 7 6 5 4 3 2 1

Contents

*For Quintilio
and in loving memory
of Joan Redmond Imperiale
and Mario Polilli*

"Skin-coveredness – All people who have depth find happiness in being for once like flying fish, playing on the peaks of waves; what they consider best in things is that they have a surface: their skin coveredness – sit venia verbo." (Taylor 97)

I would like to thank the architects who took time out to discuss the project with me, whose works and words are presented in these pages. I am deeply grateful to my friends and colleagues who have given me invaluable advice and support: Luca Galofaro, Andrea Boschetti, Brigitte Desrochers, Jack Sal, Reinhold Martin, Kadambari Baxi, Lauren Kogod, Karen Fairbanks, Celia Imrey, Cory Clarke, Luigi Prestinenza Puglisi, Ran Oron, Gianluca Milesi, Elite Kedan, Raleigh Perkins, Robert Redmond, Lawrence Blough, Laurie McCarthy, George Queral, and Brian Baer. Thanks to Maria Berman for research assistance and especially to Bob K. Cuk for research and for his inspired assistance with images and layout. David Seiple for his help in editing this text and for his insightful comments. My family, Peter, Yvonne, Laura, Daniele, Claudia, James, Sheldon, and Paolina. Thank you to my colleagues and students who have provided a fertile environment where I might test out my thoughts in these past years at both Barnard College, Columbia University and the Pratt Institute School of Architecture.

Slippery Surfaces

Postmodern theorists – like Fredric Jameson, Gilles Deleuze, and others – have made much of one characteristic feature of contemporary thought which owes little to typical modernist models of "depth." The issue of flatness and surface has assumed a critical role in the last decades of this millennium. French poet and critic, Paul Valéry once ironically noted that "the skin is the deepest" – which is an intriguing way of drawing attention to "skin" as a surface of maximum inter- face and intensity. In broad cultural terms, there has been a movement away from dialectical relationships, from the opposition between surface and depth, in favor of an aware- ness of the oscillating and constantly changing movement from one into the other.

In the context of architecture, the issue of "surface" is a recurring one. We see it in architectural discourse where in the last several years there has been a shift in emphasis to the articulation of topological surfaces in both architecture and landscape design. We see it most recently in the discussions over the aesthetics of the computer screen and other forms of digital image projection. Here the "surface" is more slippery than it might first appear. Questions regarding flatness, it turns out, are not superficial, but quite profound. In its very nature a surface is in an unstable condition. For where are its boundaries? What is its status? Is it structure or ornament?

Flatness and surface could seem to be equivalent terms in an architectural context. I'd like to distinguish between the terms as used in this book. "Flatness" refers to the paper or screen on which future architectures are projected. This issue is particularly pertinent in light of digital architecture, where one views the architecture through the screen of the comput- er. "Surface" is used to refer to issues that develop as archi- tecture is built, when the emphasis shifts from the flatness of the representational space, to the depths of the three-dimen- sional building. The relationship between flatness and surface refer then to the combination of conditions of the architectur- al product and its means of production.

This book investigates recent projects that forefront the issue of flatness and surface in their conceptual and literal construction. "Surface" is the space of flux, of oscillating conditions, and I examine this issue of flatness and surface through the work of various architectural practices. I select a number of built projects that emphasize the issue of surface and push past the real to the virtual through the visual dissolution of surface materialities. I examine digital architectural practices that utilize animation and other time-based digital technologies in proposals for built architecture. I consider the theory and production of virtual architectural space, which raises profound questions as to the nature of architecture – the real and the virtual in spatial, social, and computational terms.

1. Surface Tension

1.1 Body Surfaces

For Mark C. Taylor, everything comes down to a question of skin and bones. Bones are built-up layers of skin – pushing the limits of substance. The skin is not a straightforward simple covering of our interiority. The issue is more complex. Just as we develop from an initial division of a single cell, the surfaces grow, continually enfolding, invaginating, creating a simultaneous interior/exterior. The skin is an organ, divided internally into differentiated and interpenetrating strata. It is a surface that is continuous in its depth and, like the Klein bottle, slips from outside to inside in a continuous surface. The model of the Möbius strip and the Klein bottle drive home to us the notion that dialectical distinctions, such as inside/outside, are emptied of their meaning.

1.2 Body Image(s)

There is a long history of how one images the body. Through time this imaging has moved from the surface of the body to probing its depths. Developmentally, the body may be imagined as a continuous surface from inside to out, but there are limits to the actual envisioning and representation of that continuity. Imagative protocols range from the representation

of the three-dimensional moving body captured in the flat image – effectively freezing time – to vivid moving images of neutron firings in the brain. The imaging device may be fixed or physically mobile as it scans the immobile body. X-rays 10 register on a two-dimensional surface the invisible rays that pass through a body. In CAT-scans (computerized axial tomography) and MRI's (magnetic resonance imaging), the scanners move in a circle around the immobilized body to produce a three-dimensional digital model of the body. (Mitchell 92)

While photographic methods of scanning and imaging have had an analog relationship to the body, newer forms of body imaging technologies translate information from bodily "probings" into a universal digital binary code. Density of bone, tissue, neural impulses, blood flow – all these are registered in a precise series of "0's" and "1's." Films may be plotted from this digital information. From any point, along any vectoral path, any slice of the body may be generated. The images produced are filtered. The point here is that information that resides in the digital code for a CAT scan does not 11 have any image that is a literal cut through the body. There is no negative, as you might find in an X-ray. Rather, the CAT scan or MRI is a registration of pure information of densities of a body in space and time. Software filters are written to allow the data to be interpreted in cuts that are analogous to literal cuts through a human body.

These body images and metaphors, along with the advances in digital imaging technologies, have had a powerful influence in how we have been discussing architecture over the past several years. Digital technologies that were once used to image an already existing opaque body have been appropriated by architects and are used to project new bodies, new spaces, new architectures that are invented in the temporal digital realm. Issues surrounding the new architecture – its resistance to representation and its presence in time – lie at the core of the paradigmatic shifts that have occurred in architectural theory and practice over the last several years.

Architectural forms designed within the space of the computer are analogous to bodies moving in time. This design

1.1 BODY SURFACES

The skin is not a straightforward simple covering of our interiority. The issue is more complex. Just as we develop from an initial division of a single cell, the surfaces grow, continually enfolding, invaginating, creating a simultaneous interior/exterior. The imaging shown here maps the territory of the body's surface.

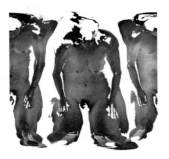 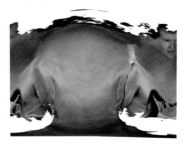

This page: Lilla LoCurto,Bill Outcault Self-portraits using cartography software from full-body laser scans, chromogenic prints mounted on aluminum. Above left: Urmayev III BL1sph(8/5)7_98, 1999. Above right: Gall Stereographic BC1sph(8/6)7_98, 1999. Bottom: Kharchenko-Shabanova BS1sph(8/6)7_98, 1999. All images approx: 48" x 60".

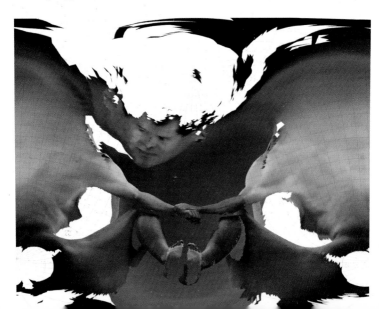

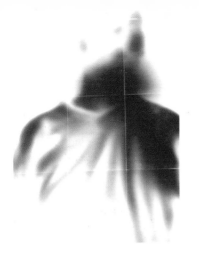

Above, Alicia Imperiale, Full-scale original negative portraits exposed in camera obscura. *Exposure time: 4 minutes, 30 sec. Below: Stelarc,* The Third Hand, *Yokohama. Robotic Third Arm prosthetic. Body inputs information into computer, left side of body receives impulses to generate involuntary movement.*

framework is a dramatic advance for architecture, and to appreciate this, we need only consider the existing struggle to represent space and time in the space of a flat sheet of paper, and how that surface relates to the access we gain in the digital realm through the space of the computer screen.

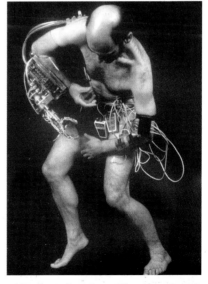

1.3 Flatness: flat paper>< flat screens?

"Skin rubbing at skin" [...]
Hides hiding hides hiding [...]
If depth is but another surface, nothing is profound...nothing is profound. This does not mean that everything is simply superficial; to the contrary, in the absence of depth, everything becomes endlessly complex. (Taylor 97)

1.2 Body Image(s)

Through time this imaging has moved from the surface of the body to probing its depths. While photographic methods of scanning and imaging had an analog relationship to the body, newer forms of body imaging technologies translate information from the probing of body in a universal digital binary code. Density of bone, tissue, neural impulses, blood flow, are registered in a precise series of "0's" and "1's".

Next page left: Various images from The Visible Human Project® *anatomically detailed, three-dimensional representations of the human body in digital form.*

Early isotopic imaging of the lungs, c. 1945.

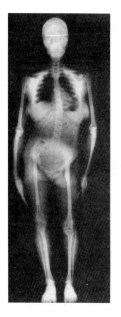 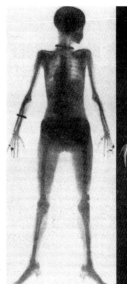 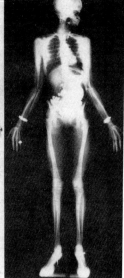

Full-body early Xray prints.

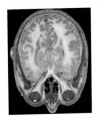

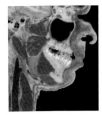

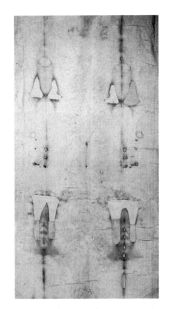

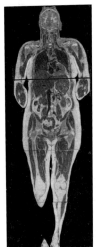

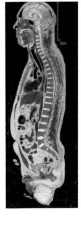

Right: the contro-versial Shroud of Turin. The shroud is layed out flat to reveal the full surface of contact with both sides of the body.

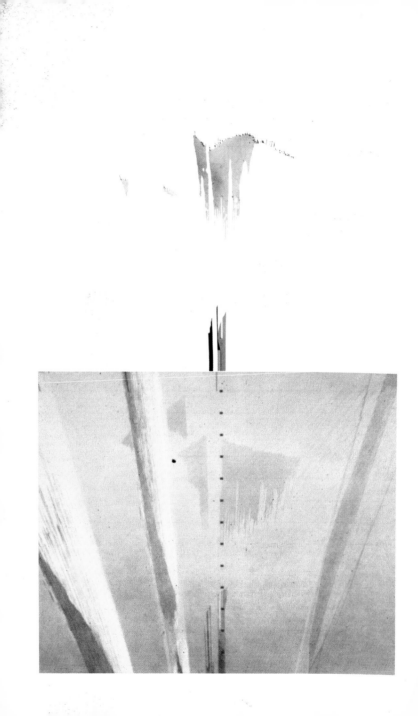

1.4 MAPPING TIME

Michael Webb challenges the limits of the flatness of the drawing surface by exaggerating speed and time, he contracts space and questions the very laws of the physical world.

This page: drawing (oil on board original) that illustrates the Henley Royal Regatta. Course markers are set up that measure a rower's speed in relation to fixed distance between markers. Through aberrations in the drawing of the perspective, Webb changes the relationship between time and space. The use of the warm colors indicates elongated time and that of the cool colors, compressed time corresponding to the energy of light waves. Left page: drawings that investigate a perspective projection as seen from above. Objects that block the view cast elongated shadows behind the object. These begin to expand as one moves further into the drawing.

In the classic science fiction book *Flatland*, a stranger (a sphere) addresses Mr. A. Square (a two-dimensional square inhabiting the surface of Flatland). The Sphere explains to the Square the concept of height (the z-dimension) that is not comprehensible in his world of Flatland. He explains that he, the sphere, a three-dimensional body, is only apprehended in the two-dimensional surface of Flatland as a circle, as a sequence of section cuts of the Sphere. The Sphere can only make all of his form manifest in Flatland by moving himself up and through the surface, thus exhibiting smaller and smaller circles until he disappears. In the plane of Flatland, one can only imagine an animate and diverse body by sequencing a series of cuts in time. How one registers spatial and temporal information in the static plane of Flatland, on a computer screen or in the space of a sheet of paper, is a question of paramount importance.

Edgar Tufte in *Envisioning Information* examines several dozen examples of drawings and maps – static images that are nonetheless rich repositories of spatio-temporal complexity. He argues that although we navigate three-dimensional space with our bodies on a daily basis (and are able to speculate on higher dimensional organizations through mathematical computation), we are continuously brought back to information displays on "endless flatlands of paper and video screen." Escaping this flatland, he says, is "the essential task of envisioning information – for all the interesting worlds (physical, biological, imaginary, human) that we seek to understand are inevitably and happily multivariate in nature. Not flatlands."

1.4 Mapping Time

12-13 Through connected drawings and text, Michael Webb challenges the limits of the flatness of the representational surface by making drawings that question our everyday assumptions about time and space. Webb asks compelling questions about the nature of creating infinite space within the computer. He wonders how one could apprehend this infinite space. Could one get to ever travel to the infinite, to the vanishing point that lies on the horizon? Webb writes, that "during rare moments

of lucidity I can accept that the journey to the horizon must be graphic and not actual and that its probing of the vast domain of perspectival space must be confined within the format of this printed page." He investigates the vastness of space in the printed space of the paper. He establishes a gridded landscape, a Cartesian space, based on a gridded coordinate system, in which he invents a vehicle for traveling to the horizon. That vehicle is one-point perspective. He explains, that "this construct provides a two-dimensional simulacrum of a three-dimensional object in space. The simulacrum is accurate only at the point of the center of vision... any part of the object featuring elsewhere within the field of vision will appear distorted: the amount of distortion a function of its distance from the point. At the periphery of the field the distortion becomes infinite. This supposed shortcoming of the construct allows the illusion of motion: that one is somehow rushing into the image." Webb's drawings question the appearance of stability. By exaggerating speed and time, he contracts space and questions the very laws of the physical world.

1.5 "Flattened Topologies"

Neil Denari has long been interested in the alliances between the graphical and the three-dimensional world. He discusses graphic design as an unwitting discipline of architecture. "If you make a plan, you can make a plan of a book cover, a house or a city all with the same series of elements, because you can distance yourself from the programmatic logic and you can talk about a particular of formmaking and that has its reductive, graphic aspect."

In his project *Interrupted Projections* for the Gallery MA in Japan, Denari continues this line of thought by pursuing a project that moves from the flat graphical surface to a folded space. The project is presented both through images of the computer animation and through photographs of the actual installation. Always concerned with the graphical as an index of consumer culture, he discusses the effect that digital technology has had on world culture – that of flattening the concept of real space into "horizontal codes of digital technologies and graphic sign-systems." He proposes an architecture

1.5 FLATTENED TOPOLOGIES

In his project Interrupted Projections *for the Gallery MA in Japan, Neil Denari continues this line of thought by pursuing a project that in its essence moves from the flat graphical surface to a folded space. Always concerned with the graphical as an index of consumer culture, he discusses the effect that the digital technology has had on world culture – that of flattening the concept of real space into "horizontal codes of digital technologies and graphic sign-systems." He proposes an architecture that is made by folding these graphically-loaded surfaces to enclose space.*

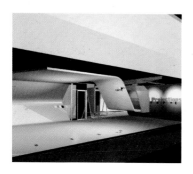

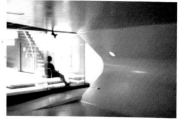

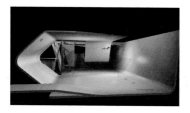

Neil Denari. Left column: digital modeling of the spaces of the Interrupted Projections. *Images at right: installation photographs at Gallery MA, Tokyo.*

that is made by enclosing space by means of these enfolded graphically-loaded surfaces. The surface he uses to produce a second skin within the Gallery MA is a smooth green, so as to confound its presence as a natural/artificial surface. The flat surface is modeled after the Homolsine map, where one can read a certain roundness even in its flat projection. He is inspired by continuous topologies (such as the Klein bottle) to produce a folded surface where there is no inside or outside. The surface of the sheet is "a prime printable (CMYK) surface," from which all geographic information has been erased. What remains is an outline of the world, which is then covered with logos and text. The projections on the surfaces proliferate, criss-cross, interrupt, flow continuously and cancel each other out. This acts as a kind of map with which the consumer might negotiate the "electronic ether in the free floating econoscape of signifiers and autonomous subjects." And, he claims, "architecture will proliferate as an intersecting agent of spatializing fabrics."

2. Architectural Surfaces

2.1 Depthlessness of Surface
In the seminal book *Postmodernism, or The Cultural Logic of Late Capitalism*, Fredric Jameson investigates the lack of depth that characterizes postmodern culture, and the significant differences between the high-modernist and postmodern moment. A critical indicator of the postmodern, he asserts, is the reduction to a literal superficiality whereby all is reduced to flatness. Surfaces now exhibit a new depthlessness. He alludes to the "cannibalization" of historical architecture styles brought together to form a new pastiche in postmodern architecture. He asserts that depth is replaced by surface, or by multiple surfaces. This depthlessness is not merely metaphorical – it is experienced literally and physically. He uses as an example of the physical manifestation of this flatness the Wells Fargo Court Building in downtown Los Angeles, describing the façade as a large floating surface that belies the volume of the building. It seems to make the very

ground seem unstable. The emphasis on the shallow, on the flat, changes the way we view the city and architecture.

Here Jameson sets the tone for the debate. Architecture, plastic, sculptural, voluptuous in its three-dimensionality, is indeed reduced to pure surface. The absolute lack of depth signals the postmodern. But this is where the story begins, not where it ends. For what might be construed as a negative critique in Portman's Wells Fargo project is rich territory for investigation for successive decades of architects. One cannot be neutral on this very point, and all architects must now position themselves in relation to the issue of surface.

2.2 Immaterial and the Transparent

"This new scientific definition of substance demonstrates the contamination at work: the *boundary, or limiting surface*, has turned into an osmotic membrane, like a blotting pad [...] What used to be the boundary of a material, its *terminus*, has become an entryway hidden in the most imperceptible entity. From here on, the appearance of surfaces and superficies conceals a secret transparency, a thickness without thickness, a volume without volume, an imperceptible quantity." (Taylor 97)

The modern period emphasized the transparent in architecture. We have since seen these matters raised further in the early 90s, for example, by the *Lightness* show at the Museum of Modern Art in New York. Only now, the issue resonates all the more profoundly. Embedded here are issues of reflectivity, slippery evanescent spaces, superimposition, and overlap with context – all of which are addressed in the works of the artist Dan Graham, in Jean Nouvel's Cartier Foundation, in Dominique Perrault's projects for the Berlier Industrial Building and in the Bibliothèque Nationale of Paris, as well as in Bernard Tschumi's project for the Karlsruhe ZKM. A fine example of this motif is provided by the extension to the museum of the Palais des Beaux-Arts, by architects Jean-Marc Ibos and Myrto Vitart in Lille, France. This is an ambiguous structure. While concrete and material in its construction, it is there and not there, visually. Barely 8 meters thick, this blade-like extension allows you to see into its depth

(painted a rich red and gold) and alternately pushes you to its surface where a web-like grid of small reflective surfaces reflect the auspicious rear façade of the neoclassical museum in a pixelated fashion. The façade is a flickering single plate of glass that brings together the impossibly distant (the neo-classical and the modern) in an ephemeral registration of depth in a single surface of glass.

2.3 Beauty is Skin Deep

On a slightly different note, many contemporary architects revisit the modernist project and are affected by the postmodern emphasis on depthlessness. The modernist project is characterized by transparency and the project of architecture is to simultaneously convey the tension between deep space and surface. The "neo-modernist" project, on the other hand, is perhaps about the compression of all depth clues to the surface of the building. While the buildings are quite visceral, they also touch on a strangely mediated experience that is characterized by the search to embody the ephemeral.

Iñaki Ábalos and Juan Herreros insistently focus on the epidermal, in both their projects and their writings, and emphasize the importance of flatness and surface in their conception of architecture. They write explicitly about moving past a modernist understanding of the literal transparency of a building's façade. The literally transparent façade was thought to be objective, to allow one to alternate between the clearly understood surface in contrast with the deep space of the interior. In their work they seek to "reclaim the autonomy of the skin" by emphasizing the differences between volume and surface. They offer an analogy with the skin of an animate body – the surface through which a body experiences the world, the surface of "maximum friction." They cite the interest in the superficial as giving a new meaning, a new depth to the quotidian, rather than privileging the sublime, or the ineffable.

In their project for Industrial Prototype Housing, Ábalos and Herreros seek to separate representation of the internal function of the building from the building's skin. In a move away from historicist illusions to the postmodern and away

20

The extension to the museum of the Palais des Beaux-Arts by architects Jean-Marc Ibos and Myrto Vitart in Lille, France, is an ambiguous structure. While concrete and material in its construction, it is there and not there, visually. This blade-like extension allows you to see into its depth (painted a rich red and gold) and alternately pushes you to its surface where a web-like grid of small reflective surfaces reflect the auspicious rear façade of the neoclassical museum in a pixelated fashion. The façade is a flickering single plate of glass which brings together the impossibly distant (the neoclassical and the modern) in an ephemeral registration in the depth of a single surface of glass.

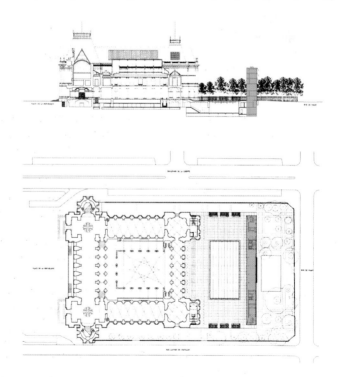

Jean-Marc Ibos and Myrto Vitart extension to the museum of the Palais des Beaux-Arts, Lille, France. This page: plan and section showing relationship of extension (in red) to existing museum. Next page: bottom left, full facade of extension shown reflecting the existing museum; top left, view of interior; right, detail photograph of the extension.

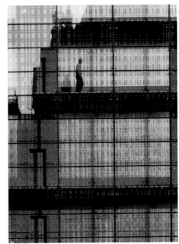

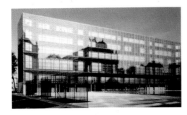

from any figuration of the exterior image of the house, they deploy a series of patterns and bright colorations on the surface of the building. They have developed a series of window panels that can permit the entire "box" to be closed down, emphasizing the graphic presence of the images. One could change images as desired, without altering the basic presence of the box. They imagine this work to be a product of contemporary material culture.

Ábalos and Herreros' project for the artist Luis Gordillo on the outskirts of Madrid investigates a similar focus. A very simple volume can alternately be fully skinned, or have the skin peeled away to reveal the interior. The luminous reflective metal skin is conceived as a fragile one, applied from without, "adhered" to the skeleton with a light tenuous touch. In contrast to the heavier base of concrete and tile, the skin seems diaphanous, extremely thin, a wall made of a skin that is folded upon itself.

Jacques Herzog and Pierre de Meuron have continually returned to their focus on the condition of skins, layers, shells, and wraps in their architecture. Their designs are generally rectilinear in plan. The view to the interior is thwarted by a

build-up of an opacity through the depth of the surfacing layers. The surfaces may be made up of more opaque materials, or else built up through layers of veiling, translucent materials. Often the exterior skinning surfaces are inscribed with figurative imagery, denoting what might lie behind the surface – literally so, in the case of the Pfaffenholz Sports Center in St. Louis, France where the swirling pattern from the building's insulation is silk-screened on the glass. The silk-screened glass sits directly in front of and in contact with the insulation. This is an emphatic comment upon the depth of skin, and they want us to understand this. The recently built project, the Technical School Library in Eberswalde, Germany, uses a serilith process whereby symbolically charged images are transferred to the building's concrete surface and directly silk-screened onto the glass. The concrete formwork is silkscreened with concrete-cure retardant (instead of ink), which prevents the concrete from curing in those areas, and is subsequently washed off. What remains is a "tattooed concrete skin." The skin is thought of as a textile or a quilt that tells a narrative. While each frame is a single image, each is bound into repetitive ribbons that encircle the building and are layered up through the building, unifying the whole.

2.4 Media Surfaces

Since the early 1970's architects have shown interest in the skin of the building as communicator. We can see this in an earlier plan for the Pompidou Center in Paris, which incorporated media screens into the face of the building. Here the influence of Guy Debord's *Society of the Spectacle* is apparent, as attention is drawn to the surface as media – an alive, flickering, constantly changing signifier. We have seen this investigated in the work of Bernard Tschumi, Jean Nouvel, and Herzog and de Meuron, among others, who think of buildings as new urban "transmitters." Façades get conceived as image sensitive film, as skins with an extraordinary capacity to communicate that might bring architecture into direct competition with the cinema or television. "The skins and surface envelope of buildings become programmable surfaces, photosensitive membranes that narrate, design and

inform the spatial organization of the volumes and interpret their functions. Information loaded walls that seduce" (Colafranceschi 96).

Bernard Tschumi has investigated these issues in numerous projects. Mark C. Taylor has written at length about Tschumi's work and describes his use of ephemeral images as the "substance" of his architecture, leading to the breakdown of the dialectical condition of surface and depth, inside and outside or public and private. In the Glass Video Gallery in Gronin- 26 gen, Holland, the glass surface is held together with transparent glass clips. The building seems to literally disappear. The projection of images seems to overlay a temporal and everchanging opacity on these transparent glass surfaces. Tschumi continues the use of video projection in the project for Le Fresnoy National Studio of Contemporary Arts. He transforms the notion of a static architecture to a notion of "electrotecture," which finds significance in the insubstantial and ephemeral. He covers a number of existing structures with an enormous roof structure and allows the marginal space that remains between the roofs of the existing structures and the new roof to be a place of serendipitous interaction and impromptu electronic projections on the underside of the roof – the *artifi-ciel*. In the Columbia University Student Center in 27 New York, Tschumi begins to leave behind the idea of video projection of electronic imagery and transforms bodies moving along "convoluted surfaces" into images – finding in the real the virtual and mediatized. The multi-level ramped space connects to other parts of the complex and contains spaces of rest and motion. In describing this project, Taylor writes: "Screens are not simply outer façades but are layered in such a way that the building becomes an intricate assemblage of superimposed surfaces. As bodies move across skins that run deep, the material becomes immaterial and the immaterial materializes. Along the endless boundary of the interface, nothing is hiding." (Taylor 96)

2.5 Folded Surfaces
If modernism sought to eradicate differences, the postmodern has been a project of seeking heterogeneity. There

2.3 BEAUTY IS SKIN DEEP

Jacques Herzog and Pierre de Meuron have continually returned to their focus on the condition of skins, layers, shells, and wraps in their architecture. The Technical School Library in Eberswalde, Germany, uses a serilith process whereby symbolically charged images are transferred to the building's concrete surface and directly silkscreened onto the glass. The skin is thought of as a textile or a quilt that tells a narrative. While each frame is a single image, each is bound into repetitive ribbons that encircle the building and are layered up through the building, unifying the whole.

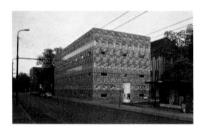

Herzog and de Meuron Technical School Library in Eberswalde, Germany. Left: overall view. Bottom: detail of the "tattooed" concrete and glass skin.

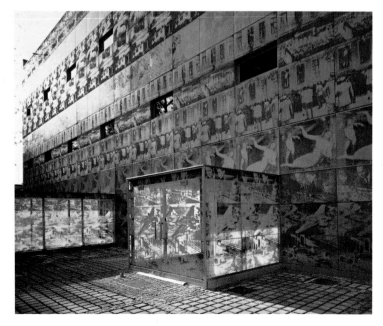

Ábalos and Herreros insistently focus on the epidermal in their projects and writings, emphasizing the importance of flatness and surface in their conception of architecture. They cite the interest in the superficial as giving a new meaning, a new depth to the quotidian, rather than privileging the sublime, or that which is ineffable.

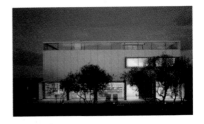

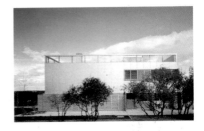

Right: various views of the Gordillo Residence, Madrid. The differing views show the house in various stages of openness of pivoting wood shutters. Bottom: Ábalos and Herrera, Industrial Prototype Housing. *Variations on the possibilities of applied surface decoration.*

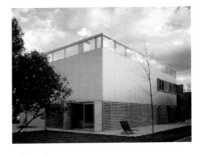

2.4 MEDIA SURFACES

Bernard Tschumi frequently uses ephemeral images as the "substance" of his architecture, leading to the breakdown of the dialectical condition of surface and depth in his architecture. In the Glass Video Gallery in Groningen, Holland, the glass surface is held together with transparent glass clips. The building seems to literally disappear. The projection of images seems to overlay a temporal and everchanging opacity on these transparent glass surfaces. In the Columbia University Student Center in New York, Tschumi begins to leave behind the idea of video projection of electronic imagery and transforms bodies moving along "convoluted surfaces" into images – finding in the real the virtual and mediatized.

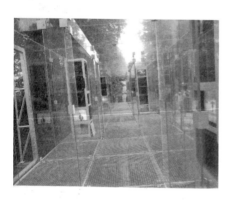
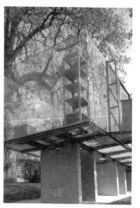
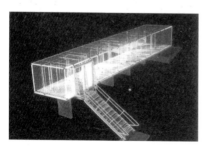

This page: Glass Video Gallery in Groningen, Holland, 1990. Top left: evanescent glass surfaces rendered opaque through video projections. Top right: exterior view of canted glass volume. Bottom left: digital rendering of structure. Bottom right: plan and elevation.

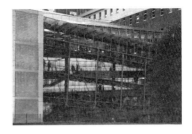

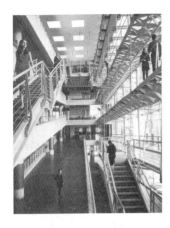

This page: top right, view into the Columbia University Student Center "in-between" space. View at night; top left, interior view of space activated by bodies in motion. Bottom: digital model of night view.

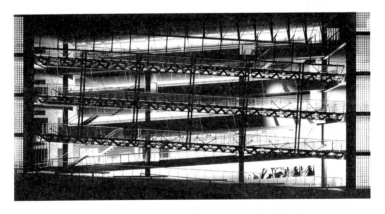

has been a break with the dialectical basis of Western metaphysics and a movement away from the paired opposites that have driven architectural thought for centuries: surface/structure; inside/outside; form/function. While these concepts are important in an architectural discourse, they also form the basis of intellectual thought and culture at large. Architecture reflects change in culture (and many believe at a painfully slow rate). We can see this in the decade-long movement away from the certainties of modernism towards a decentering, as evidenced in the deconstructionist writings of Jacques Derrida, as well as in his collaboration with Peter Eisenman. In post-

2.5 FOLDED SURFACES

The extension to the Victoria and Albert Museum in London, by Daniel Libeskind, continues the investigation of the issue of folding in architecture. The building is conceived as a spiraling surface that collapses back on itself. The sinuous movement and interlocking of the spiral spatially links the interior and the exterior of the building. The spiral is made of structural concrete, that is then clad with a new system of tile, designed by Cecil Balmond (of Ove Arup). Balmond uses the tile as a surface strategy and conceives of the tiling as a "shimmer" that runs up the spiral form. The tiling is based upon the fractal, in that the new "fractiles" are self-similar at differing scales and combine in different scalar combinations in non-repeating patterns.

This page: above, "fractile" three-tile system and spiraling diagram; bottom: possible configuration of variously colored "fractiles" used to surface the building. Next page: left, sequence of plan cuts at the various levels of the spiral; right: overall views of the maquette of the project.

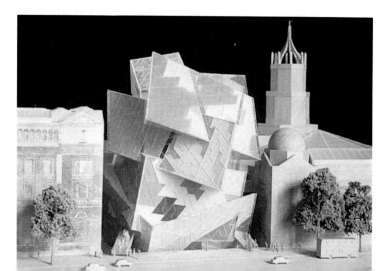

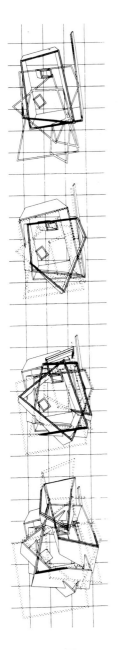

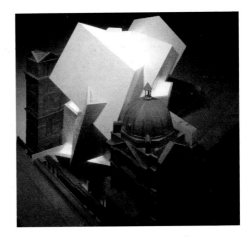

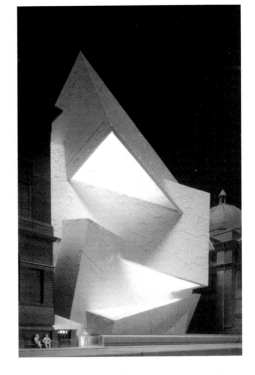

modern practice, new architectural form is created from fragments of existing form. Through a process of collage, new chimerical combinations result in infinite variations – decentering the fixed reading of architecture. Here, architectural practice is built up from the theoretical project – through writing, projects and *eventually* building.

Investigations through the 1990s have moved past the postmodern emphasis on the fragmentary towards a smoother reading of form and space. A generation of architects has moved past the writings of Derrida towards the writings of Gilles Deleuze and Félix Guattari. This brings us well past post-structuralist semiotics, and into recent developments in geometry and science, and attendant changes in political space. Architects have been especially drawn to Deleuze's *The Fold* and *A Thousand Plateaus* (Deleuze and Guattari), and interest in Catastrophe Theory (the geometry of event-space transformations) and new biology theory has led to a focus upon morphogenesis (the generation of new form). In the writing about architecture, architects have appropriated many terms from Deleuze's work – "affiliation," "smooth and striated space," "folding," "pliancy."

The incorporation of these terms into architectural thought and practice has led to significant changes in how buildings are thought of in relation to the environment. Rather than promoting a series of collisions and irreconcilable spaces as a result of heterogeneity, the influence of Deleuzian thought has been to promote smoother transitions, interactive exchanges across surfaces through serendipitous, temporary links that exist within the building site. Rather than emphasizing disjunction among primary site organization and minor site variations, there is a desire to smooth the contrasts into a new coherence.

Deleuze's work *The Fold* has had a profound influence on many architects, in both their writing and projects. In architecture, the fold may be understood as a figure (a pleat, a fold of floor planes, for example) and as a process of transformation that may be used to engender transformative change in architectural form. The fact that the fold is ambiguous, being figure and non-figure and organization and non-organization, has

been appealing to many architects who seek to move past highly figured and readily identified architectural representationality, to an architecture that is rather form-less, composed of "continuously shifting affiliations and alliances" (Kipnis 93). *Folding in Architecture* was published in 1993, before the widespread use of time-based modeling software. Just a few years later the vision of smooth space has become fully articulated through the use of time-based software such as Alias and Maya. Here forms and surfaces are generated not by a series of specific points within a Cartesian system, but loosely defined in parametric design, rather like a sphere of influence.

2.6 Mapping Surfaces

It is the flatness of the stage that makes choreography probable, just as it is the flatness of the stadium that increases the probability of athletics... The ground plane rarefies the surface of the earth in order to allow human activities to take shape. But as these surfaces become increasingly smooth and continuous, their grip is reduced to a minimum. The stairway becomes a ramp and the ground falls away. As trajectories become more precise, the slightest protrusion induces slippages. Such is the nature of the modern interval: movement on a rarefied ground that turns into an aberration (Cache 95).

A recent issue of the periodical *Quaderns* focuses on a developing sensibility regarding the landscape, both natural and urban. The emphasis is on continuity of the landscape, a smoothness, with a notable reciprocal influence of the environment on building. Farshid Moussavi and Alejandro Zaera-Polo, of the architectural firm Foreign Office Architect, describe their interest in reformulating the ground. They look beyond the classical (and modernist) understanding of the relationship between the building and ground as merely a continuation of a dialectical relationship of opposites. Their projects break down the great dichotomy between the building and the landscape, and emphasize the ambiguity between the surface and the space. The architecture is no longer a geometric, vertical volume that rises from the passive horizontal, tamed natural ground plane. "The ground becomes an active,

2.6 MAPPING SURFACES

Many designers have been investigating the redefinition of the ground as a site of continuous flux and transformation from figure to ground. They conceive of any change of the landscape as a manipulation of the surface, and charge it as a complex, mutating field. If in the modern period buildings were seen as clean platonic volumes in contrast with the flattened and tamed plane of the ground, architects are now interested in breaking down this dichotomy. They want to get past the "domestication" of the ground and look towards unpredictable changes in its "wildly different intensities."

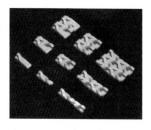

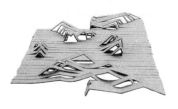

Kelly Shannon.

Foreign Office Architect (Farshid Moussavi and Alejandro Zaera-Polo).

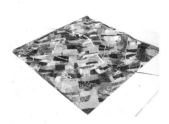

Yves Brunier, Waterloo Memorial Garden.

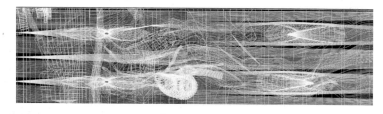

Jeffrey Kipnis with Reiser and Umemoto, Water Garden.

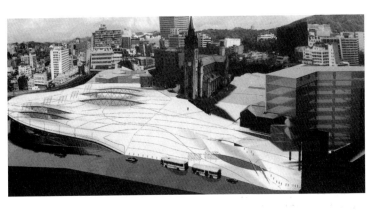

Foreign Office Architect.

NOX - Lars Spuybroek OfftheRoad_5 speed,
prefabricated housing near Eindhoven,
Netherlands.

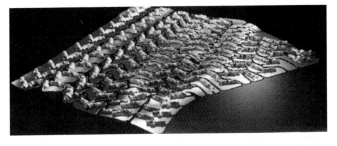

OCEAN urban surfaces.

constructed plane where the architecture emerges as an improbable, fluctuating figure."

In the same issue of *Quaderns*, Manuel Gausa speaks of "Lands in Lands" and describes an idea of landscape as a broad expanse of carpet, with smaller carpets embedded within. We will see that this metaphor applies equally well to how one works with topological surfaces in the space of the computer. Combining new structural technologies advanced through new digital technology allows one to move towards a deformation of Euclidean structures which are transformed into dynamic spaces, emphasizing the topographical rather than the volumetric.

2.7 Topological Surfaces

What the map cuts up, the story cuts across. In Greek, narration establishes an itinerary (it "guides") and it passes through (it "transgresses"). The space of operations it travels in is made of movements: it is topological, concerning the deformations of figures, rather than topical, defining places (de Certeau 84).

Ben van Berkel and Caroline Bos of UN Studio discuss the impact of new discoveries in scientific research on architecture. Scientific discoveries have radically changed the definition of the term "space," so critical in discussions of architecture. Space is understood to be topologically formed. Rather than a static model of formations, space is understood to be malleable and changeable, and its organization, division, and appropriation becomes elastic. They discuss the various effects that differential space and time have described. If you add time into the deformation, the pliability and variation of the space increase.

Topology is the study of the behavior of a superficial structure (surface structure) under deformation. The surface registers the changes of the differential space-and-time changes in a continuous deformation. This has other potentials for architectural form. The continuous deformation of a surface can lead to the intersection of interior and exterior planes in a continuous morphological change, just as in the Möbius strip.

The architects use this topological form in the design of the house, thus embedding differential fields of space and time into an otherwise static structure.

The van Berkel-Bos Möbius strip house is thought of as a continuous programmatic structure that integrates the continuous change of sliding dialectical pairs that move past each other, from inside to outside, from work to leisure activities, from supporting structure to non-supporting structure. The architects believe that the Möbius model, the Klein bottle or other non-orientable geometric structures, are interesting in that they are self-intersecting and have no enclosed interior. This can be used to attain an integral structure that is acted upon by diverse active forces – it acts like a landscape. "The surface of the Klein bottle can be translated into a channelling system, incorporating all the ingredients that it encounters and propelling them into a new type of internally interrelated, integral organization" (van Berkel 99). 36-37

These topological surface diagrams such as the Möbius strip, the Seifert surface and the Klein bottle are not used in architecture in a rigorous mathematical way, but are abstract diagrams, three-dimensional models that allow architects to incorporate the ideas of differential space and time into architecture.

3. Digital Technology and Architecture

3.1 Digital Grounding

Digital technology has not only ubiquitized media, image and communication. It also poses a radical shift in the material, technology and communications involved in the construction industry. How architecture is thought and practiced is being radically changed. Architects look frequently to other disciplines and manufacturing processes for inspiration. Architects have increasingly used complex computer-aided design and manufacturing software developed for other fields. While Frank Gehry still makes hand-made material models in the generation of form, his buildings are made possible through the use of complex aeronautical soft-

2.7 TOPOLOGICAL SURFACES

The Möbius strip house by Ben van Berkel and Caroline Bos of UN Studio is an architecture that is conceived spatially in Deleuzian terms. The project emphasizes continuous space and mathematically indeterminate space in the design of an architecture of complex topological surfaces. Topology is the study of the behavior of a superficial structure (surface structure) under deformation. The surface registers the changes of the differential space and time in a continuous deformation. This has other potentials for architectural form. The continuous deformation of a surface can lead to the intersection of interior and exterior planes in a continuous morphological change as in the Möbius strip. The architects use this topological form in the design of the house, thus embedding differential fields of space and time into the static house.

Diagrams.

Sequential floor plans.

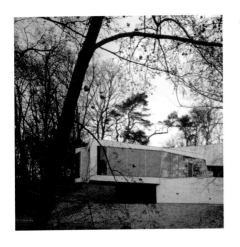

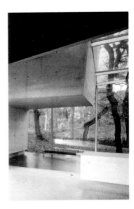

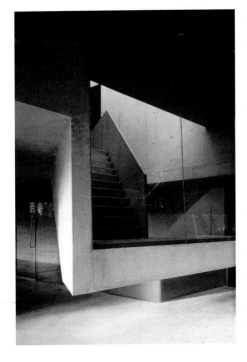

Möbius strip house by Ben van Berkel and Caroline Bos of UN Studio. Built views.

Diagram.

ware such as CATIA, which is used in the design and fabrication of aircraft. He notes with pleasure, that the Guggenheim Museum (Bilbao, Spain) was made possible through this method. The highly individual design was executed economically, on time and on budget, while pushing through the existing constraints on architecture.

Architects freely appropriate methodologies from other disciplines. This might be attributed to the fact that sweeping cultural change is registered in other cultural milieux more quickly than in architecture itself. Architects, searching to be on the cutting edge, borrow from other disciplines and believe that information from other disciplines can be readily assimilated within the architectural project. Translatability, a translation from one language to another, remains a problem. One looks for a common language with which to discuss disciplines whose boundaries are eroded. In the information age, it is interesting to note that previously distinct disciplines are linked through a common language: digital binary code.

While Gehry may utilize CATIA and other aeronautical software programs, he initiates the design by hand. In this and the following chapter, we will examine the work of a number of architectural practices which utilize the computer as form generator and site of theoretical writings. The practices forefront their interaction with the combination of software and hardware that makes up their computer set-up. Many of the programs recently appropriated for use by architects have allowed this generation to work with remarkably complex curvatures and non-Euclidean shapes that would have been inconceivable without the use of the computer and sophisticated animation software. Programs such as Alias and Maya allow the architects to simulate forces in complex and dynamically changing virtual environments that would then be proposed in built form.

3.2 Computer Numerically Controlled Manufacturing
Architects have been using CAD (Computer Aided Design) systems for the last two decades. It is only in the last few years however that the CAM functionalities (Computer Aided

Manufacturing) that we see in industrial production are being utilized significantly in architectural design. Digital resources such as this present possibilities that have tremendous impact potential. One is the possibility of continuously changing serial design in the manufacturing process. This has allowed for a re-evaluation of the modernist machine paradigm, where one was able to prefabricate singular, identical elements to be mass-produced in a factory and deployed on site in the construction process. But many architects are now investigating the seemingly liberating potential of the digital paradigm, for mass-producing practically infinite variations of elements that are then brought together to produce a sinuous, inflected architecture of variation.

3.3 The World of NURBS

A second aspect of digital technology that has a critical impact on architecture is the fact that programs such as Softimage, 3D Studio Max, Alias and Maya are calculus-based NURBS systems. This contrasts with other extensively used Cartesian-based software programs such as Auto-Cad. While these are versatile programs, it is very difficult to make fluid curves with them. They are based on point coordinate locators for every point, line, or plane in the X, Y, and Z coordinate system. In contrast, in a NURBS-based modeling system, Non-Uniform Rational Bézier Spline curves are the basis of form generation. A NURBS modeling system is quite different. Through the use of algorithmic formulas the lines and surfaces are adjusted and recalculated continuously. This is an inherently more dynamic system: surfaces and objects are developed in a shifting relation to a surface.

The Cartesian (X, Y, Z) system and the NURBS-based systems (U, V) are interlocked. The U, V system is tied into the Cartesian system through a single point. As one shifts into U, V space, one moves along a surface. All surfaces are in constant deformation. In order to create a surface, a series of weights (or spline points) are created in (X, Y, Z) space, and a line flows around the points in (U, V) space. A surface is created by the build-up of these splines and the curved surface is constantly recalculated in relation to these points.

3.4 STRIATED TO SMOOTH URBAN SPACE

Peter Eisenman discusses the issues of striated to smooth urban space in his proposal for the West Side Project. His proposal entails a shift between the striated city grid and its interaction and interference with a newly imposed smooth surface. The two systems are engaged in the computer model and are animated to pull against each other, resulting in a variable series of rips between the smooth and the striated surfaces. The programmatic elements are contained within the "ripped" spaces. Binary digital computational processes process all information in the reduced format of "0" or "1" or simple on/off or (+/-) code. Eisenman claims that the "computational paradox of (+/-) has the potential to achieve a new kind of urbanism, one with new densities and textures created by new spatial proximities."

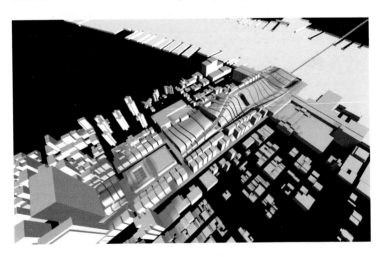

Peter Eisenman discusses the issues of striated to smooth urban space in his proposal for the West Side Project. Various digitally rendered views of the proposed project.

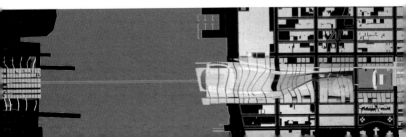

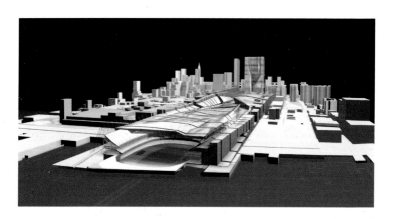

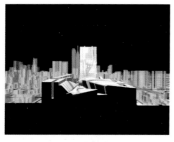
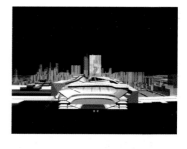

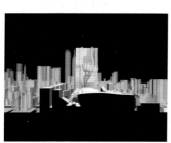
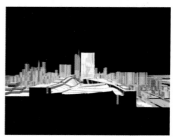

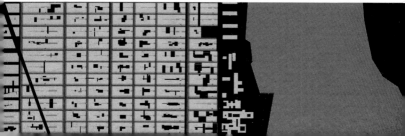

Although the spline points are located in (X, Y, Z) space, one can switch to (U, V) space and then create objects that inhabit the surface. New surfaces are embedded and developed in relation to the existing one. Similarly, the geometry itself is defined relative to the surface. If you change scale in a part of the surface, the entire surface is rescaled, recalculated.

One may design freely with complex curvatures using NURBS-based animation programs such as Alias or Maya. Greg Lynn in his book *Animate Form* points out that it is due to animation software that architects are able to "sketch with calculus" for the first time. This has had a liberating effect on the design process, allowing architects to work on topological surfaces with increasing levels of complexity and a smooth connection between landscape and building. The Deleuzian focus on smooth spaces, seriality, and dynamic processes seems to have found its perfect foil in the way one can design architectural form in a NURBS modeling system. There seems to be a smooth link between one and the other. However, one should be cautious against reducing one entirely to the other.

3.4 Striated to Smooth Urban Space

In the spring of 1999, the Canadian Centre for Architecture sponsored an ideas competition, the IFCCA Prize for the Design of Cities, that encouraged participants to reassess urban issues at the end of the millennium. The site was Manhattan's West Side rail yards adjacent to the Hudson River. Five finalists were chosen to develop their proposals: Jesse Reiser and Nanako Umemoto, Thomas Mayne (with Marta Male), UN Studio (Ben van Berkel and Caroline Bos), and Cedric Price with the winning entry by Peter Eisenman.

Peter Eisenman discusses the issues of striated-to-smooth urban space in his proposal. His design entails a shift between the striated city grid and a newly imposed smooth surface. The two systems are engaged in the computer model and are animated to pull against each other, resulting in a variable series of rips between the smooth and the striated surfaces. The programmatic elements are contained within the "ripped" spaces. Eisenman identifies a paradox in what he tentatively dubs

our "post-post modern time." If in the Machine Age, the machine was conceived in opposition to the natural, there is a strange contradiction in the machine of the computer, in that it has begun to be equated with the natural. In sheer computational speed, a computer may seem to have an artificial intelligence. The human mind must reduce some parameters and complexity in a problem, but the computer excels in processing complex data, even creating the illusion that the complexly folded and warped surfaces it generates seem to have been formed by purely natural forces. The paradox occurs in the fact that a supercomplexity may be generated that in the end appears smooth. Rather than expressing a striated space such as the urban grid, by the introduction of a high level of complexity the striated is made to seem smooth – a trait that Eisenman equates to the internal organization of felt. The weave of felt is extraordinarily dense and rather than seeming complex, seems uniform or smooth.

Binary digital computations process all information in the reduced format of "0" or "1," or a simple on/off or (+/-) code. Eisenman claims that the "computational paradox of (+/-) has the potential to achieve a new kind of urbanism, one with new densities and textures created by new spatial proximities." He equates this with the virtual. Eisenman describes the virtual as a condition of oscillation between opposites in real space. Thus in the oscillation between smooth and striated space in the design of the West Side Project, the new folded topography overflows the grid between figure and ground in an "excessive matrix of interconnectivity." Eisenman ponders how, strangely enough, this "between condition of the virtual paradoxically retrieves actual spatial content, that is the affective experience of space."

3.5 Networked Surfaces

Greg Lynn addresses issues of networked surfaces in his project for *Embryologic Housing*. Lynn's project proposes a pre- **44-45** fabricated housing prototype that consists of a networked surface composed of over 3,000 individual panels. Because the system is networked, any change in any part of the system is registered in other parts of the surface. A series of "control-

44

3.5 NETWORKED SURFACES

Greg Lynn investigates issues of networked surfaces in his project for Embryologic Housing. He proposes a prefabricated housing prototype that consists of a networked surface that is composed of over 3,000 individual panels. Because the system is networked, any change in any part of the system is registered in other parts of the surface. A series of "controlling points" are distributed across this surface so that very specific forms or "nodules" can be generated out of the non-specific surface. Lynn has developed this system so as to generate maximum differentiation in the simple configuration of the surface.

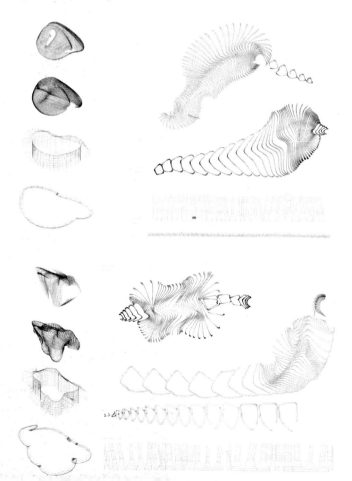

Greg Lynn FORM Embryologic Housing. *The exterior skin of the building is made from a fixed number of aluminum panels which rest on an aluminum frame and long-span tubular beams. The number of panels that make up the exterior surface remain constant in different configurations.*

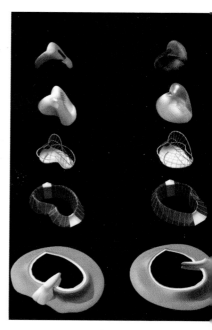

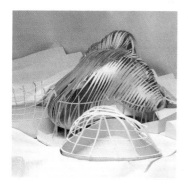

Above: the house sits in an earth berm that partially surrounds the house, with main entry on the second level. Openings for doors and windows are like tears in the surface. The upper floor is more "blobular" and has custom-fitted furniture. The lower area is a simpler excavation. Left: the drawing separates the different layers that make up the building including: metal armature, aluminum sandwich panels and photovoltaic panels. The choice of the panels allow for customization in the design.

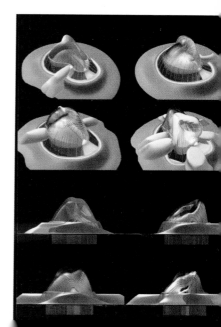

ling points" are distributed across this surface, so that very specific forms or "nodules" can be generated out of the non-specific surface. This system has the advantage of generating maximum differentiation in the simple configuration of the surface. While consistent relationships remain fixed between neighboring panels, there is change or a mutation built into the system so that no two panels are the same in any singular or multiple configuration, within certain limits and tolerances. These variations have been linked to the fabrication technology by computer-controlled robotic processes, including the cutting of metal and rubber by high-speed water jet, three-axis CNC milling of wood composite board, and computer-controlled laser stereolithography resin prototyping. The size and shape of the prefabricated panels are affected by the numerical constraints in the computer-controlled modeling technologies.

The parameters imposed on the surface-based design have explicit formal implications. The overall surface manifests change through a series of "buddings" and "elaborations" of the surface in specific areas. Window openings and other apertures are not punched through the surfaces, but are designed as tears in the surface, generating a series of "shredded and louvered openings."

These surface envelope structures do not stand alone as objects, but are conceived as an extension of the landscape. Rather than the ground exerting forces and changing the form of the surface structure, the ground reflects the action and forces in the structure. Deformations in the structure have a reciprocal effect on the "field" that it sits within, "facilitating openings, views, and circulation on a potential site."

The surfaces are designed so as to coordinate with the parameters required for manufacturing with computer-controlled milling and cutting machinery that will be used to create the models and to fabricate the full-scale panels. Eight panels make up each volume. The panels are further divided into eight curved panels or "chips." To make the volume, the panels are then arranged so that their edges are co-planar and then linked into a single surface. Two techniques will be used for fabrication. In the first technique, formwork is milled

according to these parameters and would then be used for casting ABS plastic. The individual panels would then be cut out and reconnected to create the original shape. The second technique involves cutting the panels from rubber and steel and then bending the panels so that the edges align, recreating the original shape.

3.6 Hybridization, the Chimerical

Sulan Kolatan and William Mac Donald are interested in the hybridization of the consumer project, and especially issues of sign, and of surface and communication. As an example, we can examine the relationship of a consumer object and its hybridization with building. Cut a Nike athletic shoe in half, and you find a number of cavities, layers, and bladders. The shoe, through the layering of surfaces, makes the adjustment between the body (the foot), as well as the interface and adjustment with the environment. In the analysis of the shoe, many new ideas of layering of surfaces are raised – they may be fused, sewn, constructed from silicon – and these may be used to influence materiality and construction in architecture. Surface and sectional conditions of their Raybould House 49 project suggests one of the bladders and surfaces evident in the shoe. There is of course a scalar and material shift (aluminum, stretched across ribs). Though the project is static, there is still a quality to the project, a kind of give and breathability, that brings to mind the flexibility of the shoe to negotiate the relationship between body and environment. The surface of the house is part and parcel of the idea and its production. The addition is understood as a resonating condition that mediates between the existing house and the landscape. It is thought of in those terms rather than as merely a new structure that just happens to be an extension of the existing building.

The influence of new computer technologies on their practice of space making shows in the propensity of the computer to facilitate complex network interrelationships and new chimerical hybrids. *Housings* is a project that investigates the 48 potential in the animation software program Maya to develop characters and their hybridization. In this project, Kolatan and

3.6 HYBRIDIZATION, THE CHIMERICAL

Sulan Kolatan and William Mac Donald

In the Housings *project, the architects investigate the potential in the animation software program Maya to develop characters and their hybridization. In a series of studies, they take a normative house – the base house – and then set up a series of blendings between that house and a series of target objects (consumer products). The addition to the Raybould House is understood as a resonating condition which mediates between the existing house and the landscape. It is thought of in those terms rather than as merely a new structure which just happens to be an extension of the existing building. The surface of the house is part and parcel of the idea and its production.*

Infinity Pool House, *concrete.*

Ramp House, *leather.*

Golf Course House, grass.

Shingle House, shingles.

This page: housings – blendings between the normative house and consumer objects. The new hybrids are then assigned material qualities that are used in housing and landscaping – the furnishings of domesticity.

This page: Raybould House extension.
Left: site plan showing existing rectilinear
house with the extension growing off to
the right making a transition between the landscape and the house. Right: view to
the approach to the house. Bottom: section through the house showing the interac-
tion between the existing house and the curved roof surfaces of the extension, illu-
strating the concept of bonus space.

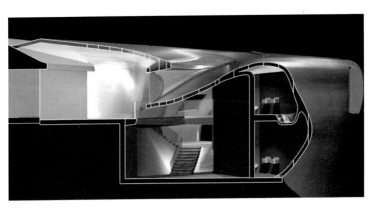

Mac Donald looked at prototype developer spec housing
throughout the country and used these models as a series of
"normative houses." In a series of studies, they take a norma-
tive house – the base house – and then set up a series of blend-
ing between that house and a series of target objects (con-
sumer products). All objects and all the houses had to be
defined in terms of the same topology, so as to be able to com-
bine them in the computer. In the combining, they began to
get a bonus effect – something unpredictable in the mixture. If
they combined a house with a boat, they got something in
between, something new, a bonus, a chimerical space, an extra

volume that exists somewhere in the house that could be built. These projects, then, investigate the articulation and inhabitation of the "bonus" spaces created by the interacting double shells.

The architects explore each house as a mix (on a sliding scale) between the experimental and the normative. Moving into the logic of construction, they search for a conceptual and structural continuity, and discover the basis for a transformative model in the changes between the normative and the more experimental condition. The computer software facilitates this process and poses interesting questions for the issue of the pre-fabrication of parts. What's especially significant is the fact that this proposal is not for a singular architecture any longer, but for an architecture that is created uniquely, with the potential of fine-tuning the design according to the particular conditions manufactured directly from the digital files. The architects produce serial sections in order to convey information to those who will construct the project. Ultimately, they are optimistic that as the technology develops, there will be a seamless electronic development of a project with all parties working on the same drawings on the Internet.

3.7 Deep Surfaces

In an essay entitled *Solid-State Architecture*, Jesse Reiser and Nanako Umemoto discuss the relationship between information technologies and building. Information technologies have brought time into the architectural discourse, and it is not an easy fit because it is easy to dismiss architecture as static, not able to incorporate time. They posit an idea about "solid-state architecture" in which the virtual informs the material. They propose to engage in a "rather untimely mixing of traditional architectural practices with emerging notions of complexity." This is accomplished by emphasizing the material economy of a building rather than its more representational or symbolic attributes – an idea that incorporates the notion of time through change in the material organization of the building. If ephemeral electronic currents are transmitted through solid material in transistors, why wouldn't virtualities co-exist in the built?

Animation and computer generation incorporate time into the design of architecture and allow for the generation of topologically complex surfaces. Andrew Benjamin develops a complex and compelling argument about how time "inheres in building," acknowledging that time is present only in certain determinations, and cites narrative time and filmic time. But time in relation to architecture is more difficult. He cites terms used by Greg Lynn (*unforeseeable*) and John Rajchman (*invention to come*) as the enfolding of the temporal in architecture. Space, considered not yet formed or indeterminately formed, inscribes the "temporality of the incomplete into the economy of the building," which then would inform the program. By avoiding one resolution, one can avoid merely formal inventions. By allowing for chance and eschewing fixed responses, time is allowed into architecture through chance – which is then translated to mean *temporal complexity* in architecture.

Reiser and Umemoto allow for temporal complexity in the thick space of the roof truss in their competition entry for the Yokohama Port Terminal by facilitating differential [57] growth. This challenges the fixed conditions of inside/outside and surface/depth. Similar to the other instances of recombinative processes described above, this allows for the combination of two elements to provide for a third, serendipitous new element. $(x + y = x + y + z)$. The "z-factor" begins to illustrate how, in breaking away from the normalizing control of the flat surface (the existing shed roof), the depth of the surface becomes apparent. This process is driven by the programmatic aim of integrating the two diverse elements (port activities and community garden space) while still keeping them distinct. The structural frame is repetitive but registers difference, illustrating Benjamin's notion of *built time*. By convoluting the surface, constantly shifting urban/landscape effects are achieved within the thickness of the roof terrain.

A similar line of thinking extends to the urban fabric. As noted before, architecture is seen as an event. Buildings are not subordinate to or separate from the urban fabric, but continuous with it. An inflection within the urban environment is

52

3.7 Deep Surfaces

Jesse Reiser and Nanako Umemoto allow for complexity in the space of the thickness of the roof truss, by allowing for differential growth that challenges the fixed conditions of inside/outside and surface/depth. Similar to other instances of recombinative processes as seen in the work of others in this book, they allow for the combination of two elements to provide for a third, serendipitous new element (x + y = x + y + z). The "z-factor" begins to illustrate how in breaking away from the normalizing control of the flat surface (the existing shed roof) that there is a discovery about how the surface contains depth. This process is driven by programmatic desires to integrate the two diverse elements (port activities and community garden space) while keeping them apart. The structural frame is repetitive but registers difference, illustrating the idea of built time. By convoluting the surface, constantly shifting urban/landscape effects are achieved within the thickness of the roof terrain.

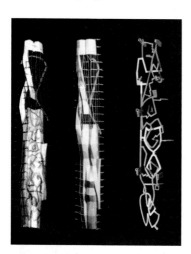

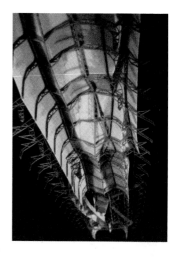

Reiser and Umemoto, Yokohama Terminal. Above left: trusses interacting with different programmatic ribbons; above right, view of underside of trusses with enclosing surface; left bottom, sectional view through trusses.

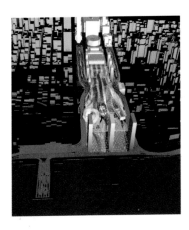
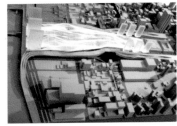

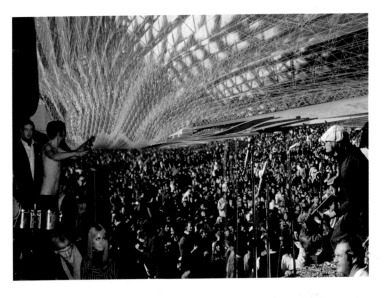

This page: Reiser and Umemoto, West Side Master Plan. The urban fabric is conceived as a "nexus of material and informational flows, developed within multiple infrastructures of transportation, distribution, culture, and knowledge." Right: Various aerial and interior views.

3.8 MOVING GLASS / DIGITAL STONE

Michael Silver Moving Glass – Toward a Fluid Transparency (Liquid Crystal Glass House) *allows for an interactive and changeable skin that negotiates the exchange between public and private space through its chameleon-like adaptation. Here, the patterns of inhabitation, labor and play are registered on the building's changing surfaces.* Digital Stone: *New York Public Library Stacks Expansion examines the connection between digital scanning techniques and digital manufacturing. The representational function of the digitizing machine is replaced by an operative strategy that is explicitly productive. In this way the scanner becomes a tool of design and not merely a technique of raw description.*

Digital Stone. *This page: top, coded mapping of different depths of model as read by the scanner; center, mapping drawing of movement of the pin in the digitizing scanner; bottom, model machined from plaster block showing library stacks as designed based on digital scans.*

Moving Glass. *Next page: above, various transformations in the liquid crystal skin; center right, truss-like structure that supports the liquid crystal panels; center left, switching diagrams. As occupants move through a series of switch-like doors, certain areas of the liquid crystal skin become alternately translucent or opaque. Bottom: view of several units attached to make longer unit.*

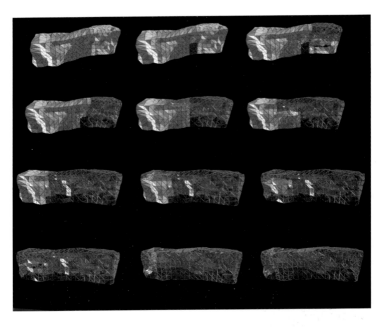

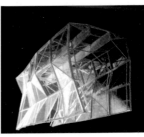

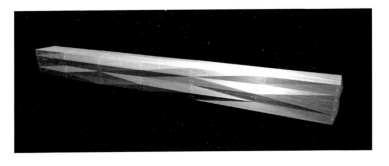

registered in building and the other way around. For this reason, architecture can hold its specificity, yet remain firmly embedded within the urban context. In their recent project 53 for the West Side Master Plan, Reiser and Umemoto have further developed this idea. They view cities, the urban fabric as a "nexus of material and informational flows, developed within multiple infrastructures of transportation, distribution, culture, and knowledge." The project rethinks the spaces for work and leisure that will be vital for the city of the 21st century.

The main program elements of the West Side Plan are conceived as an extension to the adjacent Convention Center. New civic programs are proposed: an endless (spiral) museum, concert hall, performance spaces, an Imax theater. All of these would be immersed in a park space. Different program spaces become overlapped. The park *surface* performs in various ways. It is contiguous with more civic or commercial components. This encourages a hybridization of program and organization. Modulations in the park surface create smaller scaled areas. The co-presence of the small with the large, the civic with the individual create a new kind of urban "infrastructuralism."

3.8 Moving Glass / Digital Stone

55 In his project *Moving Glass – Toward a Fluid Transparency* (Liquid Crystal Glass House, Malibu, California) Michael Silver interrogates the modernist legacy of transparency. The envelope of the building consists of a faceted metal cage covered with liquid crystal glass panels. Liquid crystal glass can thus accommodate what the fixed transparency of conventional glazing cannot, viz., the simultaneous and ever-changing need for privacy, joined with an open relationship between interior and exterior space. The liquid crystal glass allows for an interactive and changeable skin that negotiates the exchange between public and private space through its chameleon-like adaptation. Here, the patterns of inhabitation, labor, and play are registered on the building's changing surfaces. Silver explains, "like a palimpsest, the surfaces of the house register its user's activities – activities which

are by no means perfunctory, since the direction of this exchange can also work in reverse. The house is thus set in motion by the exigencies of use producing an incalculable flux that exceed both programmatic and formal description. The inhabitants change the house and the house changes its inhabitants."

In another project, *Digital Stone: New York Public Library* [54] *Stacks Expansion*, Silver examines the connection between digital scanning techniques and digital manufacturing. Located adjacent to the New York Public Library Annex on 10th Street and 6th Avenue, the project was designed to expand the limited reading and book storage space of the current facility. He explains that the form of the project was produced by taking high-resolution pin scans of small maquettes, constructed to display the existing library's internal spaces. These scans did not simply map the voids and solids of the building's interior: they also produced information determined by the constrained interaction between the scanning mechanism and the library maquettes. In this way the method of data registration was put forward as the primary agent responsible for the production of form. The representational function of the digitizing machine is replaced by an operative strategy that is explicitly productive. In this way the scanner becomes a tool of design and not merely a technique of raw description. "The map maps the mapping process." Approaching at an angle not quite parallel to the stacked floors of the annex, each scan registers a series of empty "blind spots" or "shadows" visible in three-dimensional space. These shadows were then materialized in small plaster study models using a three-dimensional milling machine.

The library's extension consists of a long wall of horizontally laid stone plates. Each plate is unique in both shape and dimension. The volumetric sample of points derived from the scanner was sectioned into layers using software designed for rapid prototyping applications. These layers are separated individually into two-dimensional templates, which would be used to design digitally cut plates of granite that would be restacked on site to form the thick enclosing walls of the pro-

ject. Books will be stored on the inward facing surface of this laminar wall.

3.9 Serial Originals

60-61 For Bernard Cache, manufacturing is theoretically grounded upon the ideas of Deleuze. In his book *Earth Moves*, he ties together notions of the surface with Leibniz's understanding of calculus, so as to allow for a network of relationships. Not pinning down a specific object or surface, but allowing for the development of "subjectiles" (variable objects created from surfaces) and "objectiles" (variable objects created from volumes), he discusses the differing inflections that can be involved in the creation of a surface. His theoretical writings are tested in the production of custom fabricated furniture and other objects. Through the use of Computer Assisted Conception and Fabrication (CFAO), a continuously changing series of complex forms are calculated. This is accomplished through the use of parametric functions in the coordinated software program. Rather than creating forms that are made up of simple contours, he envisions forms and surfaces that are generated with variable curvatures, made possible through the use of approximated curves, Béziers or splines.

This complex non-Euclidean geometry in modeling programs would permit constant adjustments to the controlling parameters and a non-standard mode of production. A different shape may be calculated for each form in a series, and this mode allows industry to produce unique objects that may be custom-made and supply "singular relations with a user," to quote Cache.

Theoretically, this form of manufacturing challenges the modern idea of the pure typological identity of a mass-produced object, which stood for equality and the normative in society. Cache does not believe that the standard model is any longer viable. He redefines the idea of the norm to "amplify the fluctuations or aberrations in our behavior" rather than to "stabilize our movements." He interprets mass-produced objects as emblems of "solidified" patterns of behavior that are not, in fact, actually characteristic of the postmodern world. The con-

temporary object, on the other hand, for Cache becomes a kind of "nodal point" through which variation occurs in a continuum. Computer numerically controlled manufacturing machines, he tells us, allow for the production of objects in the "industrial continuum." The relationship between machine and object is reversed: the object is no longer a resultant of the configuration of the machine and a "mechanical geometry." The coordination of the digital allows the architect or designer to create objects by defining the parameters to mill a surface of variable curvature.

Because the designer works on the screen by viewing three-dimensional simulations of an object, and because these simulations can be milled, Cache asserts that the image takes precedence over the physical object. The object that is manufactured is "malleable in real time" and has "lowered the status of the prototype, as well as representation of the object." The image is "no longer the image of the object but the image of the set of constraints at the intersection of which the object is created. This object no longer reproduces a model of imitation, but actualizes a model of simulation." Cache believes that the object is created at the intersection of a "field of surfaces," and believes that an electronic object's surface may become split from its function. He proposes surfaces that may interpret the digital information as a flow of "texts, information, images and sounds" and regards the function of data as creating "a sound on an acoustic membrane or, better still, produc[ing] a surface of variable curvature."

4. Virtual / Real Interface

Today many architects are using digital technology to address the interface between the real and the virtual. The architects in this section investigate various multimedia architectural environments. Several of the themes investigated include the relationship between a virtual architecture and its actual physical manifestation. Pure digital information-scapes are explored, along with their relationship to hypersurface architectures, and issues of computation become central in har-

60

3.9 SERIAL ORIGINALS

Not pinning down a specific object or surface, but allowing for the development of "subjectiles" (variable objects created from surfaces) and "objectiles" (variable objects created from volumes), Bernard Cache discusses the differing inflections that can be involved in the creation of a surface. His theoretical writings are tested in the production of custom-fabricated furniture and other objects. He believes that, through the use of Computer Assisted Conception and Fabrication (CFAO), a continuously changing series of complex forms are no longer designed, but calculated. Rather than creating forms made up of simple contours, he envisions forms and surfaces that are generated with variable curvatures, made possible through the use of approximated curves, Béziers or splines.

Bernard Cache, Objectile. *From the study of algorithmic knots Cache develops complex algorithmic formulae that mill different furnishings. Left page: acoustical standing wall panel. Seen in detail, there appears a topological landscape. Right: designs for furnishings of variable curvature. These furnishings may be custom-designed and fabricated. See the web site:* www.objectile.com

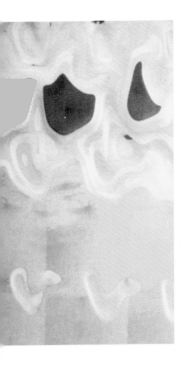

nessing the power of programming for the generation and control of space. Genetic coding in computation becomes a means of developing architectural form.

4.1 Virtual and First Reality Environments

Asymptote: Hani Rashid and Lise Anne Couture focus their practice on the overlap among virtual modeling, virtual design, virtual reality, and built space. In the I-scapes (information-scapes), they move between different geometries and materialities, and move as well towards a fluctuating flatness, in the relation of viewer to the virtual through the image on the screen. Here immersion in virtual worlds is not something new. Architects have always been immersed in the virtual. But nowadays of course we find ourselves immersed in technology itself, and contemporary architects naturally investigate the formal implications of the changing spatialities that evolve in the technology-driven design of virtual environments.

They have designed a virtual reality environment for the 64 New York Stock Exchange. This project comments on the experience of flatness. When you are immersed in a virtual reality environment, there is a fluctuation between multidimensional interface (being inside a spatiality) and the fact that you're looking at a flat screen. The oscillation between viewing the virtual reality surface and the presence of one's body in three-dimensional space heightens an awareness of the flat surface.

The architects believe that this tempers one's understanding about physical space and that, accordingly, physical space in fact plays between a kind of screen flatness and a multidimensional spatiality – one in which the body actually moves and is physically implicated. But at this point an interesting kind of "blur" occurs, in that you don't know exactly where your body actually is when you're in virtual or cyber space, and how that transfers when you're building a real space and having the body implicated in that space.

Having recently finished the virtual three-dimensional trading floor (3DTF) for the New York Stock Exchange, Rashid and Couture have been later commissioned to build the phys-

ical space. The built space appears as a kind of video image floating above the Stock Exchange Trading Floor. There are a few spatial moves such as running tickers on the ceiling, which reposition the body in the space, and which seem to be a radical move for the NYSE, because the tickers have always been on the wall. They have used light and glass in an ephemeral way and have emphasized a dematerialization of space. The architects explain that this is an interesting example of a doubling or movement between the implicit flatness of the screen and the apparent multi-dimensionality of real space, which itself can take on the characteristics of intrinsic flatness.

The architects describe the pure information space possible in the creation of virtual worlds. In the design of the virtual stock exchange, at the client's request, they began with perspectival views into a space. As the project progressed, however, they sought to minimize the conventions of perspectival projection. They encouraged their client to understand that they were inside "information space," which is not necessarily linked to real space and its representation. Here is where images and information may move at different tempos, formulating a space that is more textural, more hypertextual – where one could lose sense of one's orientation in terms of a dimensional space.

Rashid and Couture's project for the Virtual Guggenheim 65 Museum is a hybrid between First Reality and Virtual Reality. The work strives towards the breakdown of spaces and the authoritarian structure of the museum. The architects describe how the design of this virtual interactive surface involves redefining the way that museum visitors interact with objects, with other visitors, and with the museum itself. "This is a new architecture of liquidity, flux and mutability predicated on technological advances and fueled by a basic human desire to probe the unknown." Digital "sketches" of the amorphous architecture of the Virtual Guggenheim show its architecture as liquid and mutable. Visitors can manipulate the shape of the structure, resulting in a virtual museum that will uniquely remember and respond to each visitor's presence and interaction.

4.1 VIRTUAL AND FIRST REALITY ENVIRONMENTS

Asymptote (Hani Rashid and Lise Anne Couture) investigate the overlap between virtual modeling, virtual design, virtual reality, and built space. In the I-scapes (information-scapes), they move between different geometries and materialities and move towards a fluctuating flatness, in the relation of viewer to the virtual through the image on the screen. Increasingly we find ourselves interfaced with technology and the architects investigate the formal implications of the changing spatialities that evolve in the design of virtual environments.

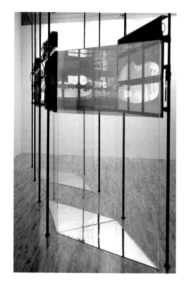

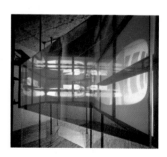

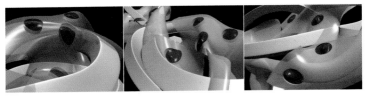

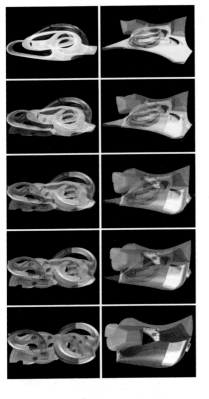

Page 64: New York Stock Exchange (NYSE). Top left: actual first reality space built from virtual reality environment. Top right: virtual reality space or "I-Scape." Bottom left and right: installation at Frederieke Taylor / TZ'Art Gallery, New York 1999, using animated projections of the Virtual Guggenheim Museum on transparent liquid crystal displays. This page: virtual Guggenheim Museum. Sequences of images of the changing surfaces in response to viewer interaction.

4.2 Multimedia Environments

68-69 Kadambari Baxi and Reinhold Martin have been working on the multimedia project *Entropia* for several years. The project began by borrowing iconic architectural and consumer items from the 1960s. They see the architectural elements and media clips as raw materials for a new design statement. The project comments on the movement from the utopic faith in modernism to the dystopia of the late 1960s.

Their study for Homeoffice merges the office tower block with the programmatic functions of the home. Through the intersecting of the two different spatial and programmatic types, a blurring occurs, as the transformation of one through the other builds up a spatial type that is manifest as skins within skins.

This work has been published as a series of architectural drawings and was revisited as a multimedia installation in an exhibit entitled "Work and Culture" in Linz, Austria. Rather than being shown as a static series of images that might indicate a final built iteration, it was shown in motion as a series of transformative images, indicating continuously flowing spaces. Martin and Baxi believe that it is not necessarily the act of building the project in concrete and glass that makes the project final – but rather its status as an interactive media project means that it is already in existence ("built").

In other words, the project is not a representation of something else to come, it is already. Typically, in architecture one makes a project that is meant to be built. When it gets built, the project is some inadequate representation of the real thing. Martin and Baxi bring the attention back, reflexively, to the project itself. If the building is built, then drawing and building would have an equivalence, it wouldn't be that the building is more important than the model, they're just different, as separate media are different. This is how they establish the relationship of media and architecture. The architecture is not just a media representation in a computer model – that computer model is already the architecture *as well as* a medium. The architecture has a 'mediality' built into it.

The latest iteration of *Entropia* is a multimedia interactive digital environment using the prior architectural project, along

with film clips and commercial advertising, as the raw material of the project. It is conceived as an archive for research, where one may re-contextualize rather than just re-present the material. In this multimedia environment, there are links to other spaces, each of which has its own sequence. They have programmed the interactive environment so that it will constantly be writing itself and causing interactions to occur – whether a person interacts with the environment or not. Here once again a "blurring" is said to occur, so that the space of interaction is an illusion – it is not a space but a surface.

As opposed to interactive educational or entertainment CD ROMs which typically depend on interaction to initiate movement, Baxi and Martin have designed an environment programmed so that it has a life of its own. If a person does *not* interact, the environment is programmed to change. As changes keep occurring, the images begin to disintegrate, to become pixelated. These pixels are the other "surface." The surfaces break down so as to reveal, in a concrete, experiential way, the abstract fact that this environment is really just made up of pixels in the end. The blurs stretch, the image is stretched past the limits of the screen towards infinity. The architects have written a program that in effect is a loop, one that will continuously transform an image. The program will continue stretching the image until it reaches infinity, even if you are not able to see the infinite image in the space of the screen. The limit is the computational capacity of the computer.

4.3 Morphogenesis

Karl Chu emphasizes the metaphysics of architecture and 72-73 computation in both his theoretical texts and architectural projects. He works with the computational capacity of the computer to investigate a "genetic architecture" through the creation of "generative surfaces." He begins by writing a simple algebraic formula that generates six primary combinations from three primary elements. He assigns each element a letter "A," "B," or "C," and translates them into splines (character strings), and studies the continued development through further generations. He doesn't begin with a geometrical premise,

68

```
on exitFrame
  puppettempo 120
  puppetsprite 24, true
  checkRollover

  set h = the height of sprite 24
  set w = the width of sprite 24
  set the height of sprite 24 to h + 2
  set the width of sprite 24 to w + 2

if the height of sprite 24 > 10000 then
    play movie "Int4.mov"
    unload movie "Int3.mov"

    puppetsprite 17, false
    updateStage
  else
    go frame 31

  end if
end

on checkRollover
  if rollover(24) then
    cursor -1
  else
    cursor 2
  end if
end
```

4.2 MULTIMEDIA ENVIRONMENTS

*Kadambari Baxi and Reinhold Martin have design-
ed a multimedia interactive digital environment*
Entropia. *They have programmed the interactive
environment so that it will constantly be writing itself
and causing interactions to occur, whether a person
interacts with the environment or not. They believe
that a blurring occurs so that the space of interaction
is an illusion – it is not a space but a surface.*

*Series of still images from the multimedia interactive CD-
ROM* Entropia. *Left: code (written by Baxi) which
instructs the computer to repeatedly expand the image until
infinity or until the computational limitation of the compu-
ter is reached and the computer crashes. This points out
that the screen is just a view into another world.*

but with a rule, an abstract system. The rule, or the algebraic formula, is open-ended in that it continues to make connections between the different elements in ever increasingly complex combinations. He uses this process to open new spatial and formal combinations that he does not predict in advance. Chu has written software which interprets the algebraic information into the generation of very complex surfaces. He explains that these surfaces are the representation of the information structures and information is represented in terms of the character strings (A, B and C) which in and of themselves have no meaning, but are the rules that allow combinations. These rules give rise to something like a topological mapping of the structure of the relationship of elements. He focuses on *how* to translate this language into geometric information. It grows out of the diagram – but there is an arbitrary decision here about the translation, in the sense that any chosen mapping of the information is just one solution out of infinite possibilities. The combination begins with the simplest combinations and then branches out in a delta formation. The branching diagram is a rule that must be translated within the X, Y, and Z axes of the Cartesian space of the computer. The focus in writing software is to translate the abstract language into geometric information. The mapping of the algorithmic information into geometric form is not automatic, but occurs in decisions made in writing the software. The information becomes the structure of interrelations of surfaces in relation to the X, Y, and Z coordinates. The evolving forms are seen in front elevation, and move into deep space back from the screen. Each image is a moment in the generation and each could move away to infinite change. The surfaces begin to fold back on themselves through an autocatalytic system – through random permutation of the algorithmic formulas. The surfaces make combinations among themselves according to these random permutations.

4.4 Hypersurface Architectures

77 Marcos Novak proposes the notion of *Transarchitectures and Hypersurfaces*, which carries with it the idea of "the transmodern" as a conceptual bridge between the solid architec-

ture of modernity and the ephemeral architecture of the virtual. He envisions continuously unfolding conceptual spaces created computationally in the space of the computer, giving rise not to a static condition, but to an architecture of becoming. He sees a continuum between space and surface in that they are both manifolds. Novak explains his complex concepts by first distinguishing between *hyperspace* and *hypersurface*. A hypersurface is the projection in three spatial dimensions of the hyperspace of four spatial dimensions. In many ways we don't have direct contact with higher spatial dimensions except through screens or sections. The act of screening simultaneously clarifies and reduces complex spatial information. Novak proposes that all that is "conceivable and presentable is already a question of incommensurable screens."

He describes the computer screen as an "interactive, intelligent surface – a hypersurface." While it seems that the computer screen is two-dimensional, it really is a surface that has a spatio-temporal dimension and allows one to interact with hypersurfaces created mathematically in the space of the computer. He believes that the screen itself is a hypersurface in that the virtual spaces are depicted through the continuously changing "matrix of physical pixels." The hypersurface of the screen is the interface between the real and the virtual. Novak discusses the hyperspaces and hypersurfaces that would be realized in the three-dimensional real space of our environment in order to create an "augmented spacetime." He sees this carried out in the work of Stephen Perrella, who 76 describes hypersurfaces: "Hyper is the existential dimension and Surface is the energy-matter substratum, parsing hypersurface into an aspect of presence and an aspect of material form." Perrella's proposals for hypersurfaces combine various superimpositions of electronic imagery on complex topological surfaces – allowing the surface to become a portal to another reality.

4.5 Blobs Built

The built project of Lars Spuybroek and Kas Oosterhuis was a temporary pavilion (1994–97) that investigates this concept of 80-81

4.3 MORPHOGENESIS

Karl Chu works with the computational capacity of the computer to investigate a "genetic architecture." His emphasis is on the metaphysics of architecture and computation. Chu is involved with the creation of "generative surfaces." He begins by writing a simple algebraic formula that generates 6 primary combinations from three primary elements. He assigns each element a letter, "A," "B," or "C," and studies the continued development through further generations.

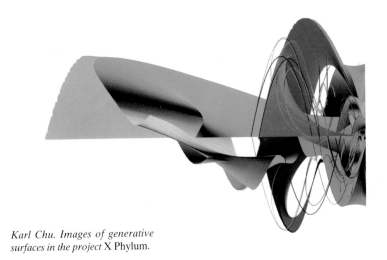

Karl Chu. Images of generative surfaces in the project X Phylum.

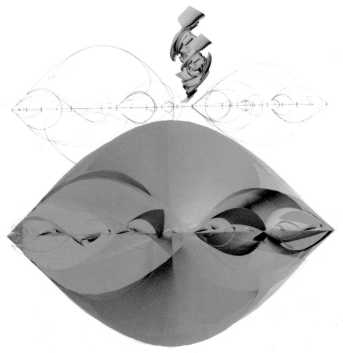

hypersurfaces. The pavilion was designed to span two bodies of water, one salt and one fresh water. The pavilions provided a kind of synesthetic experience, as a person would walk through the complexly curved non-Euclidean space. It was the architects' intent to de-center the body and de-emphasize ocular control over the spaces. The interior spaces filled and emptied with water according to tidal and wave action. In addition to the complex topological surfaces that challenged the body, a series of projections were triggered as one moved through the space.

This is one of the few built projects that incorporates complex topological forms. Does this kind of space truly liberate us from the norms and control of capitalist society? Does the use of projections really undermine the powers of control, as Deleuze clearly hopes? Or are these projections merely images that are inseparable from commercialism's ordinary media publicity. It seems that this makes for an interesting conundrum for architects at this time.

5. Time Frozen / Form Liberated?

While one works on a design within the space of the computer, the form is constantly shifting, changing, according to varying parameters. Yet there may be a problem conceptually when an image is frozen and a static architecture built from that frozen frame. Greg Lynn has discussed how a topological landscape "has virtual force and motion stored in its slopes." Reiser and Umemoto have investigated the notion of "built time." Bernard Cache discusses the constantly changing ephemeral nature of the "subjectile" and the "objectile." In the built project of complex curvature by Spuybroek and Oosterhuis, the architects depend on video projections to break down surfaces and create time-based effects. For the most part, however, architects are relying on the fluid, interactive medium of working in the computer to convey this sense of continuous change. What remains, however, is the fact that when an object or an architecture is constructed, the performative way of working in flux in the computer changes.

A built architecture or object might have virtual motion built into its slopes, but it is then dependent on other vectoral forces to release that stored energy. The activity of people or vehicles moving through an architecture would animate the space. Diurnal movement of the sun activates patterns of sun and shadow. Perhaps this is similar to Pierre Lévy's idea of the virtual as released in the act of performance.

The new technologies of NURBS-based design and manufacturing have created enormous changes in architecture in the span of a very few years. Architects have access to a new tool or instrument that allows them to design complex forms that would be inconceivable if designed by hand. It has been the intention of this work to interrogate architectural practices through the filter of "surface" and "flatness" in order to identify conceptual threads that weave through all of this kind of work but, more importantly, to interrogate also their differences – especially in their interaction with digital technology. As seen in the architectural examples in this book, these new technologies have given rise to a renewed emphasis on the issues of flatness and surface and on the surface, skin, and interface of architecture. The issue of SURFACE, when examined in terms of the computer, is most interesting because the computer is a tool *and* an ideological artifice. When you discuss surface, you can begin to explain it in terms of envelopes and skin. These kinds of descriptions of surface bring the discussion back to a more technical, performative, programmatic and environmental way of speaking of the term, one that has its roots in the language of building.

Given the fact that so many of the architects examined in this book are influenced by the work of Deleuze, there is an emphasis on looking at the world as interconnected and smooth. Yet it is utterly inconsistent with this thinking to articulate a particular kind of form (or typology above all). However, there seems to be an uncanny link between the desire to make smooth, continuous space and the way a NURBS system works. It seems that the predominance of complex curved surfaces is linked to the use of animation software. What has evolved is a dialectic of the "blob versus the box." There remains a danger, however, in that if one is

76

4.4 HYPERSURFACE ARCHITECTURES

Marcos Novak proposes the notion of Transarchitectures and Hypersurfaces, which carries with it the idea of "the transmodern" as a conceptual bridge between the solid architecture of modernity and the ephemeral architecture of the virtual. He envisions continuously unfolding conceptual spaces created computationally in the space of the computer, giving rise not to a static condition, but to an architecture of becoming. Stephen Perrella's proposals for hypersurfaces combine various superimpositions of electronic imagery on complex topological surfaces – allowing the surface to become a portal to another reality.

This page: Stephen Perrella. Top: digital models of the Möbius House. "Media infiltrations" challenge the norm of Euclidean space in a proposal for a post-Cartesian dwelling. Bottom: project for the Haptic Horizon – an informational continuity that is a result of the "emergent superpositions (seams) between background surfaces imbricated with animated texture maps containing sequences from popular culture cinema."

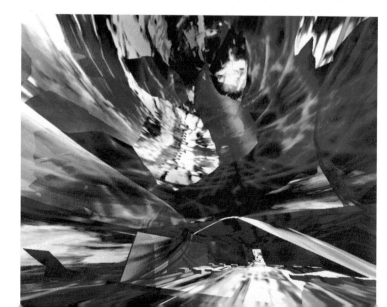

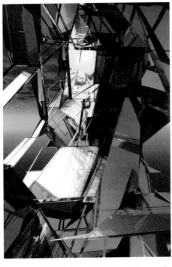

This page: Marcos Novak. Two views of TransArchitectures, *architectonic proposals that are liquid as a result of continuous algorithmic transformation. These architectures are created in the geometry of higher space and are conceived as virtual environments in cyberspace. Two images from the continuous degeneration of a paracube, using a skeleton and skin that might be deformed according to different variables and different degrees of smoothness.*

dependent on complex curvature to create continuous space, one may critique the work on purely stylistic levels.

One should be cautious in making reductive statements that would equate good design with complex form, or for that matter to denounce sinuously curved architecture as merely a stylistic choice. It is not as simple as stating that there is an architecture of curved surfaces or an architecture of flat surfaces. In *A Plea for Euclid*, Bernard Cache regrounds the notion that topology (the development of surfaces) is actually incorporated within the system of Euclidean geometry. This is an important point, which comes at a critical moment. It allows for an architecture of continuity, whether composed of flat orthographic or curved surfaces. The emphasis in all of the work on continuity of surface, flow of space, and smoothness are not inevitably tied to the necessity of articulation in curved surfaces. The use of time-based animation software such as Maya may be promulgating this bias, just as the program FormZ had emphasized a certain formal interpretation of the fold in the early 1990s. One must be critical enough to

separate how work performs on a conceptual level, on the one hand, from an equivalency in its formal manifestation as developed through a certain instrumentality, on the other. Smooth exchange, flow, continuous surface – these are concepts that are ever-present in contemporary culture. They are issues that signal paradigmatic shifts of enormous import in the relationship between man and technology – which appears more and more to be one of dissolving distinction.

6. Towards an Interdisciplinary Critique

The spectacle manifests itself as an enormous positivity, out of reach and beyond dispute. All it says is: "Everything that appears is good; whatever is good will appear" (Debord 90).

One of the most persistent challenges facing the theory and practice of architecture today is the paradigmatic shifts that are occurring because of the infiltration of information technologies on all levels of culture and experience. The impact on the practice and discourse around architecture is profound. The greatest challenge, and certainly the challenge taken up by all the architects in this book, is to avoid somehow a seemingly natural consequence of the rise of information technology – the rift between virtual space and the built or material is made even more enormous. No, the real aim has to be to discover how to incorporate technology into the *practice* of the built (in the broadest sense of practice), without being mutually exclusive. The ever-present danger here is in a euphoric embrace of technology, which privileges the virtual as liberating, free, and yet presents the material itself as incapable of expressing these virtualities. The idea should be to have one reside within the other in an expanded notion of the virtual, as expressed by Pierre Lévy, as inherently inseparable from the notion of time and performance.

The product of the architect is by necessity virtual. Drawings and maquettes are virtual indicators of a built reality to come. This built reality is mediated not only by the forces of society

and culture, but by media and capital as well. Ultimately, in order to build in the real world, an architect engages in a complex matrix of control and power. But virtual architecture, resident in cyberspace, is supposed to have escaped this dialectic. The idea of a nomadic, shifting practice is thought to allow the architect to get beyond the grasp of these issues of control. Time-based architectural production, seems to be able to slip away also, and occupy a place that is not compromised. But I believe that there are inherently very difficult issues that are not fully addressed, when the time-based animation stops and one iteration is presented as the full project. It is possible that the topological surfaces will register a potential energy for change, when built – but it is just as possible for them not to do so. Rather than dismissing these issues, we should open them for further investigation. While we can walk around the issue rhetorically, real change won't occur until we begin to grapple with the issues directly. Until then, the work will invite easy stylistic labels.

The other issue at the core of architecture, as it embraces the time-based systems inherent to information technologies, is the denial of classical, totalizing notions of representational space (here, think perspectival point of view, the panopticon). The shift is now to move away from these older systems that represent power, to an idea of representation as some kind of active vital force.

The discussion is complicated by the breakdown of the boundaries between distinct disciplines. This is simultaneously a philosophical issue that helps to define what we mean by "post-modernism," and a concrete reality that is reiterated and rehearsed on a daily basis, in the seamless communication of all information, from discrete sources into a common language of "0s" and "1s". What has emerged from the digitization of all information and practices is a universal parlance that is not tied to a single manifestation or incorporation. It is about multiplicity, variegated interconnections, blurrings. Barbara Maria Stafford has pointed out that pure interdisciplinarity is symptomatic of our times. What has occurred in the digital is the bias towards the visual, a seamless movement in the visual sign and a movement away from the word or the literary. She

80

4.5 BLOBS BUILT

The built project of Lars Spuybroek and Kas Oosterhuis, a temporary pavilion (1994–97), investigates the concept of hypersurfaces. The pavilion was designed to span two bodies of water one salt and one fresh water. The pavilions provided a kind of synesthetic experience as a person would walk through a complexly curved non-Euclidean space. The architects hoped to de-center the body and de-emphasize ocular control. The interior spaces filled and emptied with water according to tidal and wave action. In addition to the complex topological surfaces that challenge the body, a series of projections were triggered as one moved through the space.

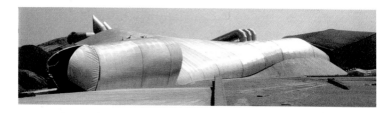

Actual built view of exterior.

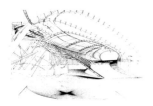
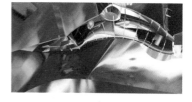

Left: computer-generated wire-frame diagram of interior space. Right: digital plan. Below: left, digital model of interior; right, actual built view of exterior.

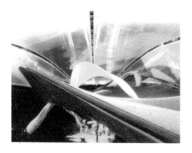

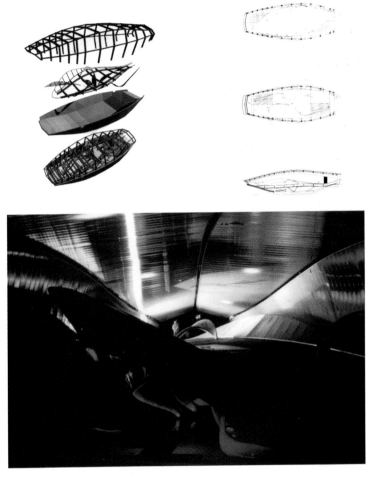

Built view of interior.

affirms many of the issues that Guy Debord raised in "Society of the Spectacle" and (for that matter) Paul Virilio in "The Vision Machine" as well. But she is not as cautionary as either of these. She fully embraces the visual in the world. Rather than seeing this as a continuation of the domination of the optical, visual mode of representation, she questions the very

epistemological underpinnings of this momentous shift. She advocates a new language, a new epistemological system that would allow one to understand and interpret visual information. She discusses the ubiquity of the image, and insists that to understand the image, which resides in the space between all disciplines, one might have to develop an interdisciplinary methodology of analysis.

Architecture, as a discipline, has not been outside of this discussion. Architecture is notoriously slow in regard to other disciplines (film, product design, fashion, multimedia) to register these rapid changes. Architects are very aware of this and seek to make their practice more culturally invested in the moment. Architects freely borrow from other disciplines. It is symptomatic of our time. As a case in point, none of the software that is being used by the architects in this book was developed for architectural practices. CAD/CAM systems, CNC milling systems, Alias, Maya – these were all developed for the manufacturing of different consumer products, automobiles, toothbrushes, airplanes, special effects for film. This kind of cross-fertilizing and borrowing from other media and other disciplines (philosophy, chaos theory, mass media theory, etc.) has enriched the practice of architecture. A cautionary note must be made however. If one borrows from contemporary culture, a critical filtering must be in place.

It is in this moment crucial to develop a dialogue that does not answer, but only raises questions. The impact that the new technologies have had across all disciplines is so profound that one must acknowledge and dispel the fear of the unknown void. If time-based architecture is able to get around the issue of representation of power, it is not adequate to say that architecture is no longer represented or representational. One must struggle for a new language, a new critical dialogue, which looks to other dissolving disciplines for a language to discuss phenomena. Allucquère Rosanne Stone, in her preface to *Electronic Culture: Technology and Visual Representation*, discusses how profound and how very new all of this is (think about the pivotal shift represented by George Lucas's Industrial Light and Magic, with their special effects for Jurassic Park, in which the real and "completely

derealized objects" co-mingle). This book seeks to reground how we think about representation, once the distinction between the real and the virtual, between our notion of self and our projected avatars, between the cyborg and the prosthetic – once all these are completely blurred. She attributes this to the fact that "we still get our idea of a stable, 'real' world muddled up with mechanisms for perceiving that world."

This last point is especially critical, and has profound implications for contemporary architectural discourse. What is at stake is more than just a discussion of media images. What is at stake is the way in which all aspects of cognition, identity and biology are challenged, through the unfolding awareness of the relation between modernity and the visual (empowered by seeing and being seen), announced in postmodern questioning of visual representational systems (Druckery 97). So, once again, all of the works here have furthered an investigation of surface that has been inititiated in the postmodern period. This necessarily problematizes the very notion of representation. With the use of new digital technologies in the design of architecture, animation and movement appear to have freed architecture and the image from issues of representation.

But might this be too simplistic? As Debord has said, the earlier periods of a new system bring experimentation that needs to be further elaborated upon theoretically. It is impossible to escape from issues of representation, and this is what is at stake now, now that we have moved past the very early stages of experimentation with digital technologies in architecture. Now is the moment to begin to develop a cultural conversation that includes an updated view of representation in an interdisciplinary language. This would make architecture and its discourse all that much richer.

Annotated Bibliography

I met Antonino Saggio to discuss the possibility of writing a book on the use of digital technology in architecture for this series almost two years ago. Digital architectural practice was a subject that I was familiar with, having curated an exhibit on young American architects with Luca Galofaro and Alberto Alessi at the American Academy in Rome, entitled: "architecture @ the edge." In the course of an intense discussion, the theme for the book began to emerge as Saggio became familiar with my own work. I am an architect who makes art. I make room size camera obsurae in which I expose photographic paper and film to register tracings of the people or spaces outside of that space. Through this work, in combination with courses that I teach regarding architectural representation, were brought together many ideas. Saggio saw in my work the recurrent issue of flatness and surface and offered the title "New Flatness" as a point of departure in reflecting upon current architectural practice in a period in which the emphasis on digital technology has signaled a paradigm shift of enormous import. This book seeks, not to make a smooth transition between disciplines and discourses that affect architectural practice, but to point out differences, varying approaches, and influences, and to posit an interdisciplinary approach to the practice and critique of architecture.

The major works that I have consulted in writing this text are as follows. More specific texts are listed in the specific paragraphs relating to each chapter.

Deleuze 93 – Gilles Deleuze, *The Fold – Leibniz and the Baroque*, University of Minnesota Press, Minneapolis 1993 (originally published as *Le pli: Leibniz et le baroque*, Editions de Minuit, Paris 1988).

Cache 95 – Bernard Cache, *Earth Moves: The Furnishing of Territories*, MIT Press, Cambridge 1995.

Taylor 97 – Mark C. Taylor, *Hiding*, The University of Chicago Press, 1997.

Mitchell 92 – William J. Mitchell, *The Reconfigured Eye – Visual Truth in the Post-Photographic Era*, MIT Press, Cambridge 1992.

Abbott 52 – Edwin Abbott, *Flatland – A Romance of Many Dimensions by A. Square*, Penguin Books, London, 1952 (originally published in London, 1884).

Tufte 90 – Edward R. Tufte, *Envisioning Information*, Graphics Press, Connecticut, 1990.

Jameson 91 – Fredric Jameson, *Postmodernism, or The cultural logic of late capitalism*, Duke University Press, 1991.

Stafford 96 – Barbara Maria Stafford, *Good Looking – Essays on the Virtue of Images*, MIT Press, Cambridge 1996.

De Certeau 84 – Michel de Certeau, *The Practice of Everyday Life*, University of California Press, 1984.

Lynn 93 – *Folding in Architecture*, Architectural Design, Academy Editions, London 1993.

Zellner 99 –Peter Zellner *Hybrid Space – New Forms in Digital Architecture*, Thames and Hudson, London 1999.

Lévy 98 – Pierre Lévy, *Becoming Virtual – Reality in the Digital Age*, Plenum Trade, New York, 1998 (trans. Robert Bononno).

Debord 90 – Guy Debord, *The Society of the Spectacle*, Swerve Editions, New York 1990 (trans. Donald Nicholson-Smith).

Stone 96 – Allucquère Rosanne Stone, *Electronic Culture: Technology and Visual Representation*, edited by Timothy Druckrey, Aperture Foundation, Inc., New York 1996.

1. Surface Tension

1.1 Body Surfaces

This section focuses on a Deleuzian discussion of the layering and folding of matter that forms all bodies as discussed in the texts: Gilles Deleuze, *The Fold* and Bernard Cache, *Earth Moves*. The mathematical models of the Möbius strip (a one-sided surface that is constructed from a rectangle by holding one end fixed, rotating the opposite end through 180 degrees, and joining it to the first end) and the Klein bottle (a one-sided surface that is formed by passing the narrow end of a tapered tube through the side of the tube and flaring this end out to join the other end) are offered as spatial models that might be incorporated in the making of architecture (see illustrations on back cover). In this chapter I bring up the human body as a site of folding and in the layers that make up a body, an opacity is formed. Artists work in the re-presentation of the surface of the body, scientists try to find ways to move past the surface to the hidden depths of the body's interior. The images on these pages are images from artists (including myself) who explore the limits of the body's surface. The flat representational surface of the photograph is critical in an investigation of flatness. Photography distinguishes itself from other art media (painting, sculpture) by the very fact that the photograph is always inextricably linked with the referent that once existed in front of the camera; the photograph *shows* us what was once really there. This describes the deictic nature of any photograph. It would therefore seem impossible to conceive of an *abstract photograph*. In my own photographic work I use the photograph as a "proof" of the abstract nature of reality. I view these photographic portraits as x-rays, as a direct tracing of that which is not seen by the naked eye, but are like the veracity of x-rays or conceptual models ($e=mc^2$). They are, all, each print, unique. Each print is a tracing, a negative that will not be reproduced. I believe that I can capture glimmers, traces of ephemera, the

spirits that surround us. *www.arch.columbia.edu/at_the_edge/ROME2000/architects/ imperiale/indexb.html.* Artists Lilla LoCurto and Bill Outcault's work is inspired by Buckminster Fuller's projection of the earth as a flattened icosahedron. They begin with full-body scans and then plot them by rearranging their binary representations on a flat surface, manifesting greater or lesser distortions in their mapped forms. *http://home. earthlink. net/~locout*

1.2 Body Image(s)

Artist Damien Hirst has produced a large body of work based on the use of animals that are cut to reveal their section. The sections of the animals are then displayed in formaldahyde-filled vitrines. Artist Rachel Whiteread dissects and turns found objects and architectures inside out. There is a fascination for the unseen, the unknown that hides behind a body's surface. The use of medical imaging has allowed us to see past the surface of the body in a non-evasive way. Prior analog methods of imaging the body's hidden interior have given over to non-optical, digital modeling. William Mitchell discusses the impact of the digital on representation in *The Reconfigured Eye*. The Visible Human Project® of the National Library of Medicine is the creation of complete, anatomically detailed, three-dimensional representations of the normal male and female human bodies in digital form. The images may be found at: *http://visiblehuman.epfl.ch/* and *http://www.nlm.nih. gov/research/visible/visible_human.html*

1.3 Flatness

The desire to express complex spatio-temporal information in the flat space of a two-dimensional sheet of paper is beautifully discussed and illustrated in Edward R. Tufte's book, *Envisioning Information*. This book establishes a point of departure for the analysis of image and movement that follows in this book. Edwin Abbott's *Flatland* is of interest here as well in giving an easily accessible understanding of the implications for the correlation between mathematics and spatial understanding.

1.4 Mapping Time

An interesting point is to compare Webb's thinking about infinity and other mathematical understandings and the construction of space evident in the thinking and work of other contributors in this book, Karl Chu and Martin/Baxi. While others are concerned with the mathematical and algorithmic basis of digital software and use this to push the limits of form and space, Webb uses the limitation of the paper as a starting point for a geometric study which pushes far into the notion of space-time. Bernard Cache writes, "Paul Virilio has rightfully emphasized the importance of speed in the perception of territory. Hence the interest in isochrone

maps, sorts of deformed territories where, for instance, Bordeaux would appear much closer to Paris than Clermond-Ferrand because the first town benefits from a fast train link. These isochrone maps certainly give shape to the perception of geographical space by train travellers. We could even go further and use a 3D curvature to manifest the coexistence of fast tracks with slower means of communication. We would then get a kind of Riemann surface with a tunnel directly linking Paris to Bordeaux, while the slower means of communications would be inscribed on the outer distended surface of the tunnel. All these phenomena are certainly topological, since it is a question of modified distances which have an impact on order and continuity. But, moreover, it is a spatial representation of distances measured in time. Topology can be very useful to analyse phenomena the dimensions of which are not restricted to the three dimensions of space. But note that those folded surfaces of isochrone maps or even isochrone tunnels can very well be represented in 3D Euclidean space. Those new representations substitute the more traditional ones and it is rather a sign of richness that Euclidean space can house several types of representation." An excellent book on the issue of mapping is a collection of essays by Denis Cosgrove (ed.) *Mappings*, Consortium Book, 1999.

1.5 "Flattened Topologies"

For a survey of the richness of Denari's architectural projects, see his new monograph: Neil Denari, *Gyroscopic Horizons*, Princeton Architectural Press, 1999. The text on "Interrupted Projections" is edited from his website: *http://parallel. park.org:8888/Japan/Sony/3DWorld/Neil_Denari*. The following text is based on an interview conducted by the author with Neil Denari in his Los Angeles office at SCI ARC, 20 May 1999: Denari does not use sophisticated digital software to set out parameters that assist in making form. Yet software has revolutionized other aspects of his practice. While he used to work primarily by designing in section, he admits that the computer, specifically the use of the program Alias (and now Maya), has changed the way he works. He now actually thinks with the computer. He operates fully in three-dimensions and doesn't draw plans and sections – a representational strategy he believes is now obsolete. In designing with the computer, once the data is entered, one can generate infinite views of the object either as static image or in animated sequence. Denari tries to use the camera angle and lighting effects in such a way that the images are not just representational – they are not just a "preview" of how the virtual space would look constructed in the "real" world. The space and form created in the computer is thus so strikingly close to the "real" that we even find ourselves wondering why it would be necessary to build them! Denari believes that it is important to build the architecture, so realistically depicted in the computer, in real space, time, and materiality.

2. Architectural Surfaces

2.1 Depthlessness of Surface
This section is based on selections from Fredric Jameson's seminal work, *Postmodernism, or The cultural logic of late capitalism*. (Thanks to Lauren Kogod for reminding me that I couldn't write on the issue of flatness without revisiting Jameson's work).

2.2 Immaterial and the Transparent
The issue of the transparent is recurrent through modern and postmodern theories of architecture. Of the many works consulted for this section were: Bernard Tschumi, *Architecture and Disjunction*, MIT Press, Cambridge 1996 and Philippe Trétiack, "Palais des Beaux-Arts De Lille – Dans le Sens de l'Histoire," in *D'Architectures d'A*, no. 75 June/July 1997.

2.3 Beauty is Skin Deep
The works consulted for this section include: Iñaki Ábalos & Juan Herreros, in *Áreas de impunidad/Areas of Impunity*, Actar, Barcelona, 1997, presented in relation to the issue of surface (thanks to Celia Imrey for this reference) and Sarah Amelar, "Two Herzog & de Meuron projects reveal deep skin," in *Architectural Record*, August 1999.

2.4 Media Surfaces
In a series of interviews with various contemporary architects, Daniela Colafranceschi in *Sull'Involucro in Architettura: Herzog,Nouvel, Perrault, Piano, Prix, Suzuki, Venturi, Wines*, Edizioni Librerie Dedalo, Rome 1996, investigates architects' obsession with the skin or the surface, or shell, of buildings.

2.5 Folded Surfaces
As discussed throughout the text, the issue of folding in architecture as influenced by Deleuzian thought is set in motion by a collection of texts and projects edited by Greg Lynn in *Folding in Architecture*, Architectural Design. In particular see the articles by Jeffrey Kipnis, "Towards A New Architecture," and Greg Lynn, "Architectural Curvilinearity: The Folded, the Pliant and the Supple."

2.6 Mapping Surfaces
Alejandro Zaera, "Reformulating the Ground," in *Quaderns 220 – Operative Topologies*, Actar Editorial, March 1999 for Foreign Office Architects.

2.7 Topological Surfaces

Michel de Certeau's *The Practice of Everyday Life* is a seminal work that culls research in anthropology, social and cultural history, and literary criticism in a search to shift the study of cultural history from the producer and product to the consumer. It has contributed to development of the notion of the performative in architectural practice.

3. DIGITAL TECHNOLOGY AND ARCHITECTURE

3.1 Digital Grounding

In the book by Barbara Maria Stafford, *Good Looking*, the author raises important issues regarding the development of an interdisciplinary language whereby images may be understood and discussed. She states that the textual has been the dominant language of communication in academia. But in this period of the proliferation of imagery facilitated by digital technology, a new analytical methodology is required. This book is critical in setting the tone for a new approach towards architectural critique.

3.3 The World of NURBS

For a very clear and concise description of NURBS-based programs and the implication of these time-based systems on architecture see Greg Lynn's *Animate Form*. This section is also based on an interview by the author with Cory Clarke. See *http://www.webreference.com/3d/lesson37/* for introduction to NURBS. For a survey of recent work in this area see *Domus*, no. 822, January 2000.

3.4 Striated to Smooth Urban Space

Eisenman's text is adapted from the text in IFCCA Prize for the Design of Cities Newspaper published in connection with the exhibit at Grand Central Terminal, Vanderbilt Hall, NY, 5-20 October 1999, Canadian Centre for Architecture, 1999. Peter Eisenman won the competition. Images courtesy of the architect and the CCA (Canadian Centre for Architecture), 1999.

3.5 Networked Surfaces

This project was chosen out of the many of Greg Lynn's work as a pure example of a surface architecture. The text is based on an interview by the author with Lynn at UCLA, 19 May 1999, and from an article by Lynn "Embryologic Housing." "Diagram Work: Data Mechanics for a Topological Age," in *ANY*, no. 23, 1998

and in *Progressive Architecture*, December 1999. Greg Lynn is groundbreaking in work in topological forms and using animation software in the design of *Animate Form*, as his recent book is titled. One may get a sense of the range of Lynn's work at the website for Greg LynnFORM: *http://www.glform.com/*

3.6 Hybridization, the Chimerical
The text is based on an interview by the authors with Sulan Kolatan and William Mac Donald in their New York studio, 28 May 1999, and the architects' unpublished project descriptions. *www.kolatanmacdonaldstudio.com*

3.7 Deep Surfaces
The text is adapted from the following books and articles: *Reiser + Umemoto: Recent Projects,* Academy Group Ltd., Great Britain, 1998, foreword by Daniel Libeskind; Andrew Benjamin, "Opening Resisting Forms." *Reiser + Umemoto: Recent Projects*; and the "IFCCA Prize for the Design of Cities," Newspaper. Images courtesy of the architects and the CCA (Canadian Centre for Architecture), 1999. *www.arch.columbia.edu/at_the_edge/ROME2000/architects/reiser_umemoto*

3.8 Moving Glass / Digital Stone
Michael Silver, adapted from unpublished project descriptions and interview. *www.virtualglass.com*

3.9 Serial Originals
In all of Cache's writing we see an interlacing with the writing of Deleuze. His manufacture of serial produced original products is an exploration of his theories in practice. As Gilles Deleuze writes in *The Fold*, "the new status of the object no longer refers its condition to a spatial mold – in other words, to a relation of form-matter – but to a temporal modulation that implies as much the beginnings of acontinuous variation of matter as a continuous development of form... The object here is manneristic, not essentializing: it becomes an event." *www.objectile.com*

4. Virtual / Real Interface

4.1 Virtual and First Reality Environments
The following text is based on an interview conducted by the author with Lise Anne Couture and Hani Rashid in their New York office, 10 June 1999. *www.asymptote-architecture.com; www.asymptote.net*

4.2 Multimedia Environments

The following text is based on an interview conducted by the author with Kadambari Baxi and Reinhold Martin in their New York office, 9 August 1999. *www.arch.columbia.edu/at_the_edge/ROME2000/architects/martin_baxi/* I would like to specifically thank Reinhold Martin for discussing his ideas regarding surface and parametrics with me. Our discussion was instrumental in confirming my own ideas regarding surface and the notion of surface as an oscillating condition was important in development of the preface: "Slippery Surfaces."

4.3 Morphogenesis

The text is based on an interview conducted by the author with Karl Chu in his Los Angeles studio, 18 May 1999, and his writing from "Diagram Work: Data Mechanics for a Topological Age," in *ANY,* no. 23, 1998. *www.lacn.org/trans/ default.html*

4.4 Hypersurface Architectures

Novak 98 – "Transarchitectures and Hypersurfaces: Operations of Transmodernity" from *Hypersurface Architecture. www.aud.ucla.edu/~marcos/.* Stephen Perrella, "Hypersurface Architecture," in *Architectural Design Profile,* no. 133, John Wiley and Sons, London, 1998. *www.columbia.edu/~sp43/hypersurface.html* Michel Serres 1983a [1977]. *Language and Space: From Oedipus to Zola,* in *Hermes: Literature, Science, Philosophy* (Josue V. Harai and David F. Bell, eds.), The John Hopkins University Press, Baltimore.

4.5 Blobs Built

Lars Spuybroek, "Motor Geometry," and Kas Oosterhuis, "Salt Water Live," from *Hypersurface Architecture, Architectural Design Profile,* no. 133, 1998, and *Domus,* September 1997. The work of Oosterhuis/NOX may be found on the Internet at: *www.oosterhuis.nl* and *www.lenard.nl.* "Architects, it would seem, are particularly susceptible to an aesthetic that fetishizes the ephemeral image, the surface membrane. The world becomes aestheticized and anaesthetized. In the intoxicating world of the image, the aesthetics of architecture threaten to become the anaesthetics of architecture." Neil Leach, *The Anaesthetics of Architecture,* MIT Press, 1999, p. 45.

5. TIME FROZEN / FORM LIBERATED?

"A New Generation is shaking up the architecture profession with grandiose digital designs. But how many of the cyberarchitects' buildings will ever be built?"

(Alexander Stille, "Invisible Cities", in *Linguafranca – The Review of Academic Life*, special issue: *Technology – or Treachery*, July/August 1998). In this article, Stille traces the development of working within the digital realm. He states that many of the "cyberarchitects" are content to think and write and project architecture but do not actually build. I think that this is not quite correct. These architects want to build. The emphasis on the CNC milling and other manufacturing interfaces in these practices point to these issues. What emerges as the more critical point in my mind is the contradiction between the utopic belief in the liberation that is evident in working with "animate form" and its allusion to the virtual and the theoretical defense of the work when built as being able to sustain its virtuality. I believe that this is a point that warrants further investigation beyond the scope of this text.

Caroline Bos and Ben van Berkel describe another aspect of the change in their practice that expands the idea of topological surfaces to include the issue of time: "Time is on the architect's side. The invention of new, time-based techniques expands the imagination, explodes the hierarchy of the design process and encourages the input of different disciplines. To redefine organisational structures means that if the information on which a building is based possesses proportions that work and it sounds right, it can take any form; blob or box – it doesn't matter anymore. The best effects that architecture can produce now are proliferating and moving, effects that are unfolding, anticipatory, unexpected, climactic, cinematic, time related, non-linear, surprising, mysterious, compelling and engaging." Caroline Bos and Ben van Berkel, *UN Studio, MOVE*, UN Studio Goose Press, 1999.

Bernard Cache, excerpted from, A Plea for Euclid "Nowadays, in our digital age, does the computer compel us to think and live in a multidimensional, non-Euclidean, topological space? Or shouldn't we instead consider the computer as a variable compass, which will open new potentialities within the old Euclidean space? Because topology doesn't register any difference between a cube and a sphere, it focuses on what is left, order and continuity. Order and continuity are also essential to Euclidean geometry. Euclidean geometry includes topology. Topology is less than Euclidean geometry... Because topological structures are often represented with indefinite curved surfaces, one might think that topology brings free curvature to architecture, but this is a misunderstanding. When mathematicians draw those kind of free surfaces, they mean to indicate that they do not care about the actual shape in which topology can be incarnated. In so doing, they should open the mind of architects and allow them to think of spatial structures before styling them as either curved or squared. And, of course, as soon as it comes to actually making a geometrical figure out of a topological structure, we enter into Euclidean geometry; that is, the design of complex curvature is essentially Euclidean. One

should not think of Euclidean geometry as cubes opposed to the free interlacing of topology. On the contrary, it is only when variable curvature is involved that we start getting the real flavor of Euclid. Willingly or not, architects measure things, and this implies a metric. Only by mastering the metrics, can we make people forget Euclid. Many unexpected figures will then enable us to incarnate complex topologies in Euclidean space. We have only caught a whiff, we haven't really tasted it yet!" *http://www.architettura.it/extended/ep07/ep07en_03.htm*

6. TOWARDS AN INTERDISCIPLINARY CRITIQUE

Three works that are essential to begin discussing and interdisciplinary dialogue are Pierre Lévy, *Becoming Virtual – Reality in the Digital Age* (thanks to Andrea Boschetti for this reference), Allucquère Rosanne Stone, *Electronic Culture: Technology and Visual Representation*, and Barbara Maria Stafford's *Good Looking*. Catherine Ingraham points out in her recent book *Architecture and the Burdens of Linearity*, Yale University Press, 1998, that the breakdown or merging between disciplines is already curiously present. She posits a thought-provoking argument that contains an underlying paradox in thinking about the issue of disciplines and the discipline of architecture in particular: "Disciplines, because they have myths of formation, carry within themselves the sense that at one point in time they did not exist. But because disciplines are founded somehow, they are often described as being founded on something that was not previously part of the discipline, on something that existed before their formation. But in architecture particularly, the founding of the discipline on the ground of something else (philosophy, building, the need for shelter) is complicated by the almost ubiquitous condition of architecture as a discipline that is the collection of many bodies of knowledge. The architect is a generalist, a collector of disciplines... But I have always been interested in the strangeness of the architectural discipline – its fatal dependence on other discourses, its abjectness in the face of power, its collectivity. I think the ligatures among the bodies of knowledge... that the architect must somehow 'possess' (or know the mechanism for possessing) typically keep architecture in an ongoing state of discipline formation – never finished, always underway."

The Information Technology Revolution in Architecture is a new series reflecting on the effects the virtual dimension is having on architects and architecture in general. Each volume will examine a single topic, highlighting the essential aspects and exploring their relevance for the architects of today.

Series edited by **Antonino Saggio**

Other titles in this series:

Information Architecture
Basis and future of CAAD
Gerhard Schmitt
ISBN 3-7643-6092-5

HyperArchitecture
Spaces in the Electronic Age
Luigi Prestinenza Puglisi
ISBN 3-7643-6093-3

Digital Eisenman
An Office of the Electronic Era
Luca Galofaro
ISBN 3-7643-6094-1

Digital Stories
The Poetics of Communication
Maia Engeli
ISBN 3-7643-6175-1

Virtual Terragni
Young American Architects
Christian Pongratz / Maria Rita Perbellini
ISBN 3-7643-6174-3

Natural Born CAADesigners
Young American Architects
Christian Pongratz / Maria Rita Perbellini
ISBN 3-7643-6246-4

New Wombs
Electronic Bodies and Architectural Disorders
Maria Luisa Palumbo
ISBN 3-7643-6294-4

Digital Design
New Frontiers for the Objects
Paolo Martegani / Riccardo Montenegro
ISBN 3-7643-6296-0

For our free catalog please contact:

Birkhäuser – Publishers for Architecture
P. O. Box 133, CH-4010 Basel, Switzerland
Tel. ++41-(0)61-205 07 07; Fax ++41-(0)61-205 07 92
e-mail: sales@birkhauser.ch
http://www.birkhauser.ch